" The iconic clenched-fist salute offered up by African-American athletes Tommie Smith and John Carlos during their medal ceremony at the 1968 Olympics in Mexico City did not occur in isolation—it came in the spirit of similar protest actions at sports events, all around the world. In *Playing as if the World Mattered*, the reader discovers in brilliant detail what has been true all along: that sports has always been more than a game."
— Sam Tracy, author of *Bicycle! A Repair & Maintenance Manifesto*

" Sport as politics, particularly radical resistance against tyranny, is an exciting and crucial part of our history. It amazes me that it has taken so long for this story to be told. It is intensely fascinating and academically scrupulous. What an addition to the world's understanding of one of our great passions!"
—Meredith Burgmann, former president of the Australian Council for International Development

" Gabriel Kuhn has sh FIFA or the IOC migh en
bedfellows but have enjoy<
—Will Simpson, author of *Fr* *e*
Easton Cowboys and Cowgirls

" Gabriel Kuhn is not concerned with moral reflections about how to approach sports and politics. Instead, he provides practical examples of how sport is already politicized and portrays supporters—and even athletes—as progressive social forces."
—Ekim Çağlar, *Flamman*

" Creativity and solidarity are as indispensable in sport as they are in social struggle. If you have any doubt, read this book."
—Wally Rosell, editor of *Éloge de la passe: changer le sport pour changer le monde*

Playing as if the World Mattered

An Illustrated History of Activism in Sports

Gabriel Kuhn

Playing as if the World Mattered: An Illustrated History of Activism in Sports
Gabriel Kuhn
© 2015 PM Press.

ISBN: 978–1–62963–097–7
Library of Congress Control Number: 2015930879

Cover by John Yates / www.stealworks.com
Interior design by briandesign

10 9 8 7 6 5 4 3 2 1

PM Press
PO Box 23912
Oakland, CA 94623
www.pmpress.org

Printed in the USA by the Employee Owners of Thomson-Shore in Dexter,
Michigan.
www.thomsonshore.com

Contents

"All movements are resistance." Print by Dylan Miner (www.dylanminer.com).

Introduction

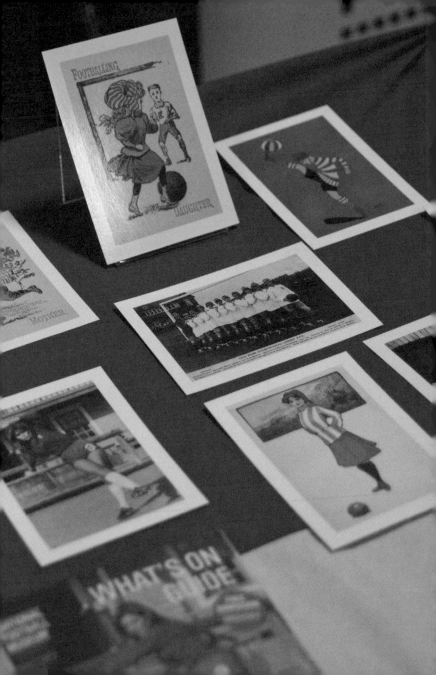

While sport has received increased attention within the political left in recent years—not least in connection with an increased interest in popular culture in general—anti-sport prejudices remain. The prominent Marxist Terry Eagleton has stated that "it is sport, not religion, which is now the opium of the people" (in *The Meaning of Life*), while, in the anti-sport treatise *Barbaric Sport: A Global Plague*, Marc Perelman declares that "in the pestilential environment oozing out of sport, the question arises: what can critical theory come up with today against sport now it has become the visible face of every society? The only possible critical response is a firm assertion: *there should be no sport.*"

It is easy to criticize sport from a left-wing perspective. There is plenty of bigotry and machismo. The global administration of sport reflects Eurocentrism and (neo)colonialism. Commercialism and celebrity cults run amok. Sport is tied into the worst kinds of nationalism and chauvinism. Competitiveness, perhaps the most crucial ingredient of a capitalist culture, often becomes most tangible in sport. Sport is used for political propaganda, sometimes by the most unsavory of politicians. Sport contributes, perhaps ironically, to unhealthy ideals of fitness and beauty, and millions of kids go through traumatic experiences during "physical education." It is also true that sport does serve as an opiate for the masses. Yet, how much of all this depends on sport, and how much on the social and cultural circumstances sports are played in today?

This book is not about reclaiming some supposedly genuine leftist value in sport, buried by capitalist alienation. Sport is a combination of things—exercise, play, catharsis, and more—that aren't tied to any particular political brand or value system. Sport's political meaning is created by the way it is exercised, and by the social place it occupies. This, however, challenges us to take sport

Exhibition "A Woman's Place Is…" by **FC United of Manchester** (see page 101), 2013. Photograph by Mark Van Spall.

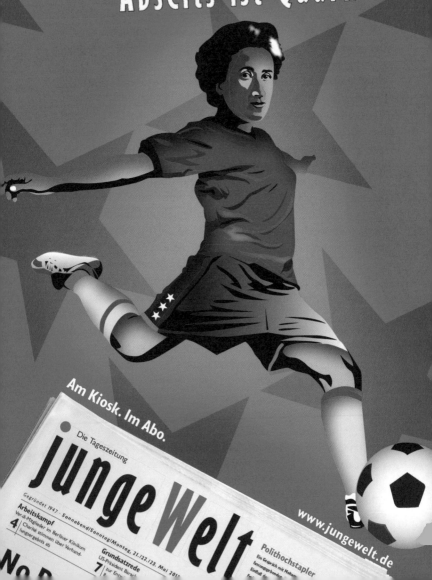

seriously and to create circumstances that bring out the best in it, not the worst. Perhaps most importantly, sport won't go anywhere. People will want to exercise, play, and release their emotions in the most free and egalitarian of societies. Besides, sport occupies the minds and hearts of many more people than radical caucuses or anticapitalist debates do. To brush this aside as a mere matter of brainwashing is dangerously patronizing.

As much as we need to create liberated forms of economic production and distribution, political decision-making, scientific research, and artistic expression, we need to create a world of sports that fits the picture. The guiding principles are comradeship, fair play, empowerment, social learning, and community. People have followed these principles and tried to create corresponding environments since the inception of organized sports in the late nineteenth century. Some chapters of this history are fairly well known, for example Muhammad Ali's refusal to serve in Vietnam or the clenched-fist salute Tommie Smith and John Carlos offered at the 1968 Mexico Olympics; others are almost forgotten, such as the workers' sports movement of the early twentieth century; and some have always lingered underground, like the worldwide web of grassroots and community sports clubs. This book aims at unearthing these chapters of sports culture for a better understanding of the struggle for both better sports *and* a better world.

As suggested by the book's title, images will play a major role in telling the relevant stories. This follows the simple truth that an image can say more than a thousand words. The fact that the accompanying texts are kept short is the result of basic economic calculations: producing a full-color book that is reasonably priced demands a limit in size. However, each section has a listing of

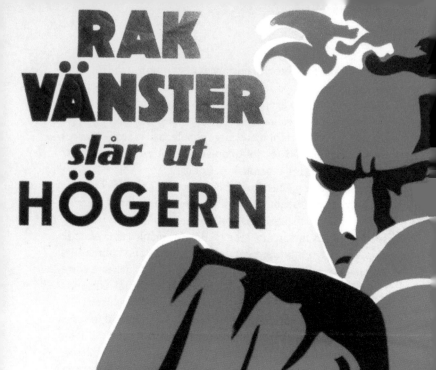

RAK
VÄNSTER
slår ut
HÖGERN

Rösta med
Kommunisterna

publications, films, websites, and other resources that allow the reader to dig deeper into areas of particular interest.

Chapter 1, "Workers' Playtime: The Workers' Sports Movement (1893–1945)," retraces the history of the workers' sports movement that emerged at the end of the nineteenth century, experienced its heyday in the early 1930s, and was destroyed by fascism shortly after. Workers' sport was a mass attempt at using sports as an essential tool in the fight against the bourgeoisie and capital, simultaneously paving the way toward a socialist society. As a radical attempt at changing the entire characteristics of sports on such a grand scale it remains unrivaled.

Chapter 2, "Fair Play for the People: Sports and Civil Rights (1946–1989)," portrays the civil rights struggles in sports during the post–World War II period. With the workers' sports movement in shatters (or only surviving in tame, compromised forms), broad visions for a radically different world of sports were gone. But this didn't stop athletes, managers, fans, and journalists from trying to influence the world of sports in a progressive manner. This chapter revisits events of the era such as Jackie Robinson breaking the race barrier in U.S. Major League Baseball in 1947 and the soccer players at Corinthians in São Paulo, Brazil, challenging both the restrictions of the professional athlete and the authority of the military regime in the early 1980s.

Chapter 3, "From the Ground Up: Grassroots Organizing in Sports (1990–present)," outlines today's grassroots and community sports movement; a movement combining elements of community organizing, DIY (do it yourself) ethics, and direct democracy, and growing stronger by the day as a result of

Election poster by the Swedish Communist Party, 1944: "A straight left knocks out the right. Vote with the Communists!" Courtesy of Arbetarrörelsens arkiv och bibliotek, Stockholm, Sweden (www.arbark.se). Artist: Nils Brädefors.

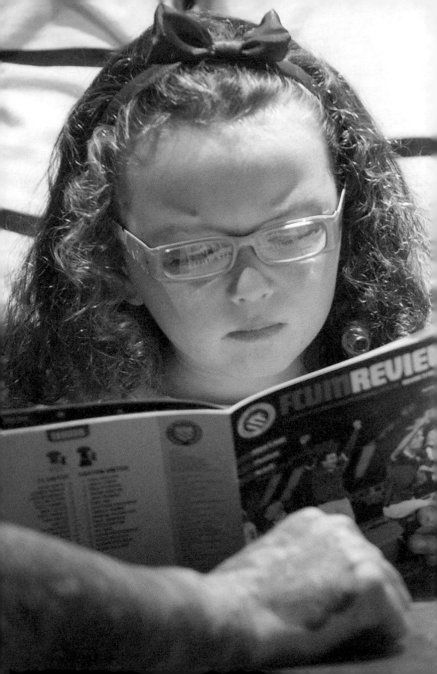

disillusionment with a world of sports reigned by greed, corruption, and power mongering.

A tremendous thank you is due to all the artists, photographers, and archivists who have made this project possible. Any detailed list would inevitably be incomplete, which is why all such attempts have been abandoned. You know who you are!

Perelman's above-quoted book was originally published in French as *Le sport barbare: critique d'un fléau mondial* (2008); the English edition appeared in 2012. More traditional left-wing critiques of sport can be found in Jean-Marie Brohm's text collection *Sport: A Prison of Measured Time* (1989, French original 1976). Brohm was a central figure in the critical sports journal *Quel corps?* (1975–1997) and is also involved in its successor *Quel sport?* (since 2007; see www.quelsport.org). A recent, and more balanced, study of sports under capitalism is *Sport in Capitalist Society: A Short History* (2013) by Tony Collins. For accounts of some of the worst consequences of sport in capitalism, Joan Ryan's classic study *Little Girls in Pretty Boxes: The Making and Breaking of Elite Gymnasts and Figure Skaters* (1995) comes recommended as well as Regan McMahon's *Revolution in the Bleachers: How Parents Can Take Back Family in a World Gone Crazy Over Youth Sports* (2007) and Tyler Hamilton's first-hand account of doping among elite cyclists in *The Secret Race: Inside the Hidden World of the Tour de France: Doping, Cover-ups, and Winning at All Costs* (with Daniel Coyle, 2012).

For affirmative sports writing from a left-wing perspective in English, the books by Dave Zirin are mandatory, especially if your main interest is U.S. sports. Both *What's My Name, Fool? Sports and Resistance in the United States* (2005) and *A People's History of Sports in the United States: 250 Years of Politics, Protest, People, and Play* (2009) make good starting points. You can find a full list of Zirin's books, as well as additional articles, on the website www.edgeofsports.com. Other books addressing sports from a left-wing perspective are Robert

A young sports fan reading the zine of the community football club FC United of Manchester. Photograph by Matt Wilkinson (www.wilkinson-photo.com).

*Sports*ACTION

Chronology & *Communiques* of Anti-2010 **Resistance** & *Direct Actions*

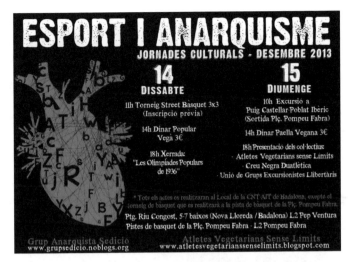

L. Simon's *Sports and Social Values* (1985), Gary Genosko's *Contest: Essays on Sports, Culture, and Politics* (1999), Gabriel Kuhn's *Soccer vs. the State: Tackling Football and Radical Politics* (2011), and Matt Hern's *One Game at a Time: Why Sports Matter* (2013). For academically inclined readers, William J. Morgan's *Leftist Theories of Sport: A Critique and Reconstruction* (1994) may also be worth a look.

There are a number of blogs of interest to left-wing sports fans. Jennifer Doyle maintains www.thesportspectacle.com (Doyle's former blog www.fromaleftwing.blogspot.de remains archived), DIY-type blogs include www.lefthookjournal.wordpress.com (Canada), www.pickedlastsports.com (USA), www.inside-left.blogspot.com and www.footballisradical.com (both UK), and numerous interesting articles in English can be found at www.idrottsforum.org.

Top: Flyer for a Sports and Anarchism conference in Badalona, Catalonia, December 2013.
Left: Cover page of a zine documenting protests against the 2010 Olympic Winter Games in Vancouver, Canada, compiled by the editors of the www.No2010.com website, 2008. Both private collection.

Freie Sportwoche

·Zeitschrift für Fußball, Leichtathletik und Turnen·

Erscheint wöchentlich. — Redaktion und Verlag: Leipzig S 3, Fichtestraße 36. — Telephon Nr. 30 418 und Nr. 30 289.
Preis der Einzelnummer 28 Pfennige. von 2 Nummern an 25 Pfennige.

Nummer 17 Leipzig, den 27. April 1927 9. Jahrgang

Zum 1. Mai

Erwache, Volk, erwache!

Workers' Playtime: The Workers' Sports Movement (1893–1945)

ARB. TURN u. SPORTVERBAND Č. S. R.

1. BUNDES.

TURN.

KARLSBAD

FEST

9.-11. AUG. 1924.

Origins

The organization of sports in associations, leagues, and tournaments was a result of the late nineteenth century's bourgeoisie filling its newfound "leisure time" with activities. As European workers earned more of such "leisure time," too, they began to participate in these activities in increasing numbers. This got workers' movement leaders concerned about the influence of bourgeois sports clubs on the proletarian rank and file, and they responded by establishing their own sports organizations.

It was in Germany where the workers' sports movement first bloomed. After the abolition of the "Socialist Laws," which prohibited socialist organizing in Germany from 1878 to 1890, several workers' sports associations emerged: the "Worker Gymnasts Association" (*Arbeiter-Turnerbund*, ATB) was founded in 1893 (renamed *Arbeiter-Turn-und-Sportbund*, ATSB, in 1919); it was followed by similar associations for swimming, sailing, track and field, bowling, and chess.

Germany was not the only country, however, where workers' sports organizations were founded, and the phenomenon was not reduced to Europe either. In Argentina, numerous sports clubs were established by socialists, among them the still-existing Argentinos Juniors (originally Mártires de Chicago), El Porvenir, and Chacarita Juniors. In Japan, the socialist Abe Isoo saw so much communitarian spirit in baseball that he, successfully, campaigned for establishing the sport at Japanese universities—an effort that led to baseball being one of Japan's most popular sports, and to Isoo being posthumously inducted into Japan's Baseball Hall of Fame. In South Africa, the trade unionist Bernard Lazarus

Poster for the "First National Gymnastics Festival" in Karlsbad/ Karlovy Vary, 1924, organized by the "Workers' Gymnastics and Sports Association of Czechoslovakia." Private collection.

DIE FREIE TURNERIN

ARBEITER-TURNVERLAG A.-G., LEIPZIG / FRITZ WILDUNG, LEIPZIG, FICHTESTRASSE 36
8. JAHRGANG * LEIPZIG, AM 29. DEZEMBER 1921 * NUMMER 7
ERSCHEINT VIERWÖCHENTLICH / REDAKTIONSSCHLUSS 10 TAGE VOR ERSCHEINUNGSDATUM

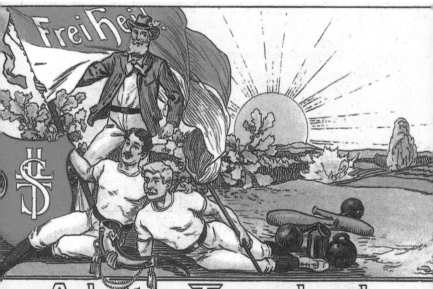

Sigamoney organized numerous integrated sporting events in an effort to overcome the racial boundaries plaguing the country.

Europe, however, remained the center of the workers' sports movement. At its heart stood the fight against individualism, competitiveness, and commercialism. Instead, it stressed the values of community, health, and sportsmanship. Running competitions were replaced by hikes in the countryside; swimming races by lifesaving courses; duels in wrestling or tennis by noncompetitive gymnastics and cycling; "tournaments" by "sports festivals"; "national teams" by "federations"; "performance mania" by "physical exercise." In 1933, the Austrian Social Democrat Hans Gastgeb summed up the goals of workers' sport thus: "For the worker athlete, mass sport and political education are one. Sport is not practiced for distraction, but as a necessary means to shape a proletariat that is mentally and physically able to overcome political, economic, and cultural reactionism and capitalism."

The main programmatic text of the workers' sports movement is *Sport und Politik* (Sport and Politics), authored by the Austro-Marxist Julius Deutsch in 1928. Deutsch was the president of the Socialist Workers' Sport International (see below). In the following excerpts, Deutsch explains the difference between "bourgeois" and "proletarian" sport:

> Let us look at what they try to present to us as *neutral* sport, but which we clearly must identify as *bourgeois* sport: It reveals itself in its purest form during the pompous events meant to satisfy people's craving for sensation. These events are advertised weeks in advance and attract tens of thousands of spectators who, in a collective frenzy brought on by all the latest manipulative tricks, watch some record

Top: Caption of the "Free Female Gymnast," a journal published by the ATB/ATSB from 1908 to 1926. Bottom: Postcard by the "Workers' Gymnastics Association," early 1900s. Both private collection.

Frauenturnen Spiel u. Sport

Bibliothek der Leibesübungen

Arbeiterturnverlag A.G. Leipzig

chasers compete for a big prize—yet another marketing tool. The more brutal and dangerous the sport, the bigger the attraction....

Bourgeois sport is entirely focused on individual record. Record, and record again. This is the magic word. Enormous happiness seems to come when a high jumper clears one meter ninety instead of one meter eighty-five.... But the bourgeoisie's fanatic focus on records is no coincidence. *Bourgeois sport is individualistic sport. That is its deepest essence.* The collective achievements of mass sport count for nothing compared to an individual record.... Therefore, *as a matter of principle*, the working class has to reject bourgeois sport with its focus on records and professionalism as an expression of the nature of capitalism. *It is not true that it is neutral.* It is the result of a particular social and cultural order whose destruction is the proletariat's historical task and moral duty....

Workers' sport cannot be individualistic; otherwise, it will destroy itself. Workers' sport is, in its deepest meaning, collectivist.... The goal of proletarian sport is the strengthening of the masses.... Workers' sport aims at— and can only aim at—the harmonic fitness of the entire body.... The recklessness and the brutality which we often encounter on sports fields are characteristic for bourgeois sport. Workers' sport hardly knows of any such instances. This is no coincidence. It is the consequence of these two kinds of sport being of very different natures.

The workers' sports movement was not only an essential part of the proletarian culture of its time, but it also granted the

Cover of the pamphlet "Women's Gymnastics: Play and Sport," published by the "Workers' Gymnastics Press A.B. Leipzig." Private collection.

Nr. 1 Januar 1914 6. Jahrgang

Deutsche Arbeiter-Schachzeitung

Monatsschrift zur Förderung der Schachspielkunst in Arbeiterkreisen.

Herausgegeben und redigiert von **M. Wingefeld**

unter Mitwirkung von
H. Martin = Stuttgart
H. Fiedler = Nürnberg

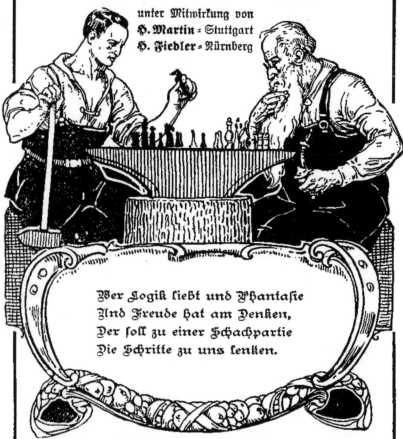

> Wer Logik liebt und Phantasie
> Und Freude hat am Denken,
> Der soll zu einer Schachpartie
> Die Schritte zu uns lenken.

.. Geschäftsstelle für Oesterreich-Ungarn: Franz Wickls Verlag, Wien I. Bestellungen, Zahlungen, Lösungen und sonstige Sendungen sind an die Redaktion der .·. Deutschen Arbeiter-Schachzeitung, München, Landshuter Allee 14 Rgb., zu richten. .·.

"average worker" significantly more influence than most workers' organizations. As the historian Robert F. Wheeler writes, "In fact, there was probably no other component of organized labour in which rank-and-file interaction was greater.... International congresses might pass resolutions about understanding and solidarity but labour sports could, and frequently did, provide practical manifestations of these ideas."

The main English publication on the Workers' Sports Movement is *The Story of Worker Sport* (1996), an anthology edited by Arnd Kruger and James Riordan. The historians Robert F. Wheeler and David A. Steinberg have contributed several articles in academic journals. Among the numerous histories in German are *Arbeitersport* (1929) by Fritz Wildung, *Frisch, frei, stark und treu. . . Die Arbeitersportbewegung in Deutschland 1893–1933* (1973) by Horst Ueberhorst, and *Illustrierte Geschichte des Arbeitersports* (1987), edited by Hans Joachim Teichler and Gerhard Hauk. A sample of Julius Deutsch's writing on sports will soon be available in English (see page 35). For people who enjoy digging in archives, Socialist Workers' Sport International congress reports (available in various languages) are well worth exploring. Film aficionados may enjoy the 1929 documentary *Die Frau im Arbeitersport* (Women in Workers' Sport).

Cover of the "German Workers' Chess Journal: A Monthly Journal to Promote the Art of Chess Among Workers," no. 1, January 1914. The poem reads: "He who loves logic and imagination / And he who enjoys thinking / Shall direct his steps toward us / For a game of chess." Private collection.

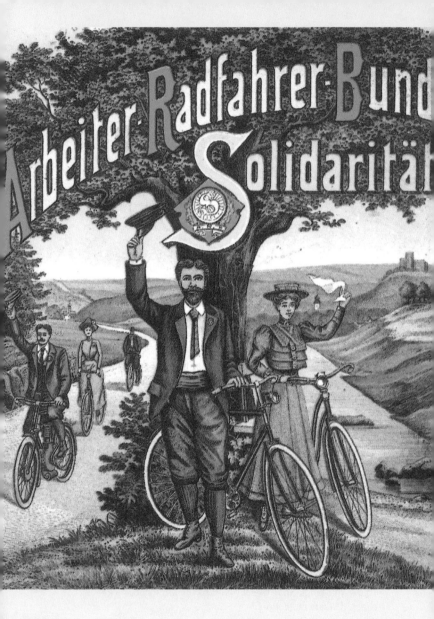

Postcard by the "Worker Cyclists Association 'Solidarity,'" early 1900s. Private collection.

ARB Solidarität

A particularly important workers' sports organization was the German "Worker Cyclists Association 'Solidarity'" (*Arbeiter-Radfahrer-Bund*, ARB, *'Solidarität'*), founded in 1896 (renamed *Arbeiter-Rad- und Kraftfahrerbund*, ARKB, *Solidarität* in 1928). The ARB *Solidarität* became not only one of the biggest workers' sports organizations, but, peaking at three hundred thousand members in the 1920s, it was one of the biggest cycling organizations world-wide, maintaining its own bike factory, workshops, inns, cottages, and insurance systems. Environmental considerations weren't central at the time; the political significance of cycling focused instead on the bicycle as an affordable means of transport that allowed a new freedom of mobility for many workers. In some European countries, the bicycle was also used for political agitation. In Sweden, "red bicycle patrols" of the syndicalist SAC covered thousands of miles in the summers of the 1930s in order to recruit even in the most isolated communities. In Britain, the still existing National Clarion Cycling Club, founded in 1894, also has socialist roots; today, it promotes "on-bike social networking."

Like all German workers' sports organizations, the ARKB *Solidarität* was banned by the Nazis in 1933. It was refounded in 1945 but dropped the term *Arbeiter* (Workers) from its name twenty years later. Today, few visible connections exist between the organization and the historical workers' movement.

Unfortunately, the history of the ARB *Solidarität* is not well documented in English. The only book on the topic is Ralf Beduhn's *Die roten Radler: Illustrierte Geschichte des Arbeiterradfahrerbundes "Solidarität"* (1982). The story of the National Clarion Cycling Club is told in the book *Fellowship Is Life: The Story of the Clarion Cycling Club* (2004) by Dennis Pye.

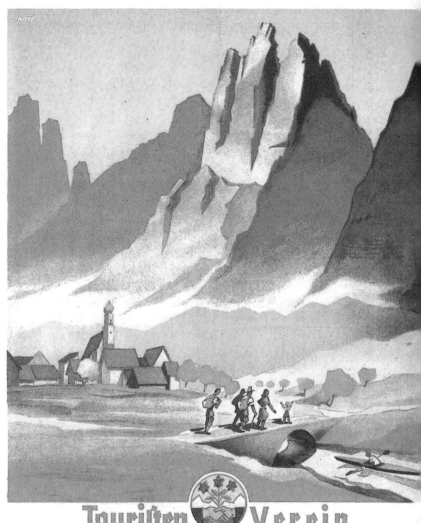

"Tourist Association Friends of Nature" poster, ca. 1920. Private collection.

Naturfreunde

Another important workers' sports organization was the *Naturfreunde*, or "Friends of Nature," founded in Austria in 1895. The *Naturfreunde*, self-advertized as a "tourist organization," encouraged workers to go for walks and hikes during their free time rather than spending it in environments considered destructive, like inns and gambling houses. The organization built hiking trails and cottages and soon expanded beyond Austria's borders. In the early 1930s, branches existed in over twenty countries and the total membership was at two hundred thousand. The organization's crest—a handshake beneath three Alpine roses—was designed by the Social Democrat Karl Renner, later the prime minister and president of Austria. In a speech given in 1931, Renner claimed that "the *Naturfreunde*—together with all other sports organizations and cultural and intellectual expressions of the workers' movement—are not a distraction from the socialist goal; rather, they spread socialism in its truest form, a socialism that impacts all aspects of human existence and nourishes them in democratic organizations."

The *Naturfreunde* were among the few workers' sports organizations able to consolidate again after World War II. Sadly, very little of their working-class roots remains.

Focusing on the *Naturfreunde* in Germany, Dagmar Günther's *Wandern und Sozialismus. Zur Geschichte des Touristenvereins "Die Naturfreunde" im Kaiserreich und in der Weimarer Republik* (2003) is a great book. In 2005, the organization itself released the chronicle *Berg frei—Mensch frei—Welt frei! Eine Chronik der internationalen Naturfreundebewegung von den Anfängen der Arbeiterbewegung bis zum Zeitalter der Globalisierung (1895–2005)*. The website for the International Friends of Nature (IFN) is www.nfi.at; it hosts a digital library.

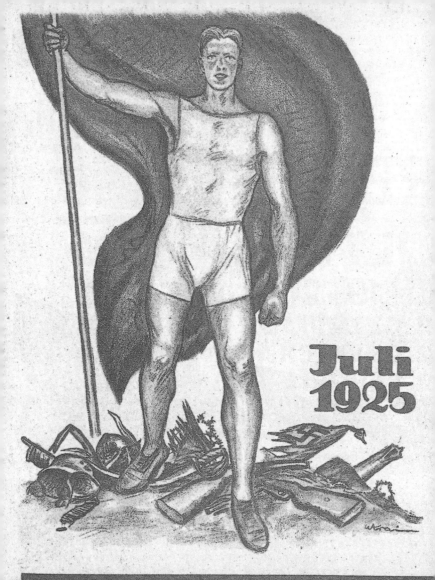

Juli
1925

I. Internationales Arbeiter-Olympia
Frankfurt am Main

PLAKATKUNSTDRUCK ECKERT, BLN.-SCHÖNEBERG

SASI and the Workers' Olympics

In 1920, the Lucerne Sport International was founded as an international umbrella organization for workers' sports associations. In 1928, it was renamed Socialist Workers' Sport International (usually referred to by the acronym SASI after its German name: *Sozialistische Arbeiter-Sport-Internationale*). SASI was closely linked to the International Trade Union Confederation and the Labour and Socialist International (today the Socialist International). In 1931, SASI had almost 2 million members, most of whom hailed from Germany (1.2 million), Austria (300,000), and Czechoslovakia (200,000).

Many sports events were organized under the auspices of the SASI. The biggest by far were the Workers' Olympics. The first took place in 1925 in Germany; the winter games were held in Szklarska Poręba (in present-day Poland), the summer games in Frankfurt. The guidebook of the Frankfurt games explains the intention of the Workers' Olympics:

> The bourgeois Olympic Games will always be marred by the "unspirit" of nationalism, since the capitalist world knows no true reconciliation. Our Olympics are based on understanding and reconciliation between the peoples. In our Olympics, nations do not compete against each other, but athletes from all countries compete together as comrades. . . . We all have the same enemy: capitalism, which has created and nurtures nationalism. We do not give laurel wreaths to nations, and we do not fly their flags;

Poster announcing the "First International Workers' Olympics" in Frankfurt, Germany, 1925. Note the smashed arms and the torn Nazi flag on the ground. Private collection.

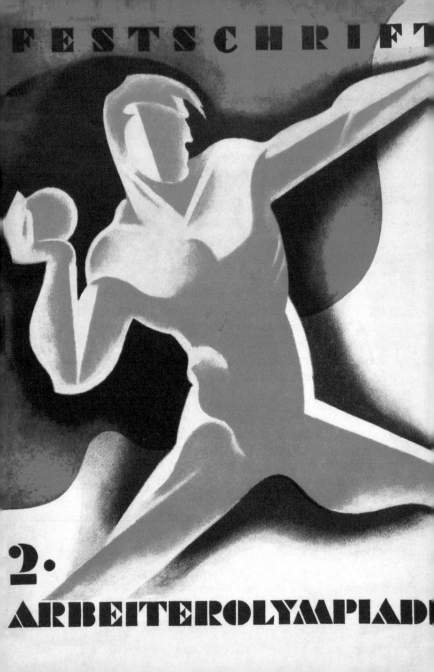

instead, we unite as brothers and sisters under the flag of socialism.

Several thousand athletes from twelve countries participated in the Frankfurt games. Most events were held in the newly built *Waldstadion*, still Frankfurt's biggest sports arena. There was also a rich cultural program, including parades, operas, and a "living chess game."

The second Workers' Olympics took place in Austria in 1931. The winter games were held in Mürzzuschlag, the summer games in Vienna. There, too, a new stadium was built for the games, the *Praterstadion* (today *Ernst-Happel-Stadion*), which remains Austria's national arena. The number of participants had risen to about twenty-five thousand, hailing from twelve countries. Eight cyclists had come from Palestine—by bicycle. During the opening ceremony, four thousand workers enacted the history of the working class; the performance ended with the collapse of an oversized capitalist's head. As in Frankfurt, no national flags were flown and no national anthems played.

Julius Deutsch's pamphlet *Unter roten Fahnen! Vom Rekord- zum Massensport* (Under Red Flags! From Records to Mass Participation in Sports) was released for the Vienna games. Essentially, it is a summary of *Sport und Politik* (see page 23). An English translation will be included in a book with selected writings by Deutsch titled *Antifascism, Sports, Sobriety: Forging a Militant Working-Class Culture*, forthcoming from PM Press in 2016. Special treats are the games' guidebooks (*Festschriften* in German) if you can track them down. There is a great documentary film about the Frankfurt Olympics, *Die neue Großmacht* (1925); in July 2012, it was screened as *The New Great Power* at Tate Modern in London.

Cover of the guidebook to the "Second Workers' Olympics" in Vienna, Austria, 1931. Private collection.

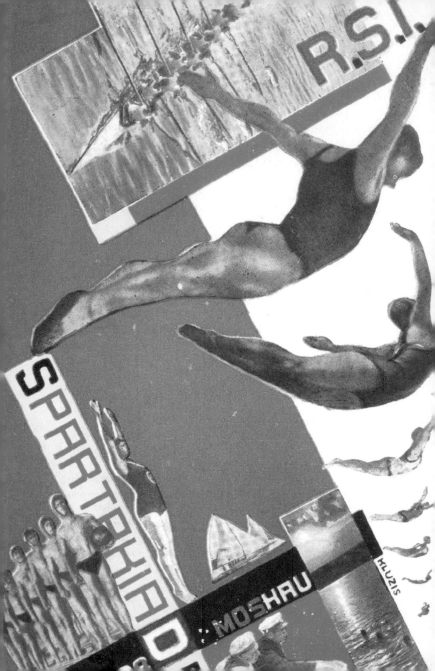

RSI and the Spartakiads

In 1921, communist sports organizations founded their own international body, the Red Sport International (RSI). It was a rival organization to SASI, which was dominated by Social Democrats. The RSI was based in Moscow and closely linked to the Comintern. In 1931, its membership was slightly higher than SASI's, but two million members came from the Soviet Union alone. Outside of the country, RSI affiliates could only rival their Social Democratic counterparts in Czechoslovakia and Norway.

The goals of the RSI and SASI were very similar: sports should be used to strengthen the consciousness and the physical strength of the working class, and counteract the negative ideological influences of bourgeois sports clubs. For the RSI, these goals were closely linked to the Soviet model, while SASI propagated a more vaguely defined proletarian culture.

The relationship between the RSI and SASI were strained from the beginning. The conflict came to a head before the first Workers' Olympics in Germany. As a result, RSI organized athletes were not allowed to participate. The ban was upheld six years later in Austria. In Germany, all Communist Party members were excluded from SASI-affiliated associations in 1928. As a reaction, Communists founded the "Syndicate to Reestablish Unity in Workers' Sports" (*Interessengemeinschaft zur Wiederherstellung der Einheit im Arbeitersport*), which was renamed "Action Group for Red Sport Unity" (*Kampfgemeinschaft für Rote Sporteinheit*) in 1930, colloquially known as *Rotsport*, or "Red Sport." *Rotsport* was particularly strong in Berlin and the industrial areas of Saxony and the Ruhr Valley.

The rival events to the SASI's Workers Olympics were the Spartakiads, huge sports festivals combining elite competition

Poster for the 1928 Spartakiad in Moscow. Private collection.

with mass outings. Spartakiads remained the most important sporting events for state socialist countries until the 1950s. The first time a Soviet team was sent to the Olympic Games was in 1952. While not an official RSI event, the Communist Party USA sponsored a 1932 "Counter-Olympics" in Chicago, while that year's official games were held in Los Angeles.

The standard history of the RSI is *Die rote Sportinternationale 1921–1937. Kommunistische Massenpolitik im europäischen Arbeitersport* (2002) by André Gounot. It is not available in English, but several essays by Gounot are, for example "Sport or Political Organization? Structures and Characteristics of the Red Sport International, 1921–1937" (*Journal of Sport History* 28, no. 1, Spring 2001). A comprehensive academic study of sport in the Soviet Union is Susan Grant's *Physical Culture and Sport in Soviet Society: Propaganda, Acculturation, and Transformation in the 1920s and 1930s* (2013). On the Chicago Counter-Olympics, see *Red Chicago: American Communism at Its Grassroots, 1928–35* (2007) by Randi Storch for background information, and the article "Muscular Marxism and the Chicago Counter-Olympics of 1932" by William J. Baker (*International Journal of the History of Sport* 9, no. 3, 1992). For a great selection of Spartakiad images, see "Spartakiade: A Bolshevik alternative to the Olympics" at www.thecharnelhouse.org. The website www.spartakiad.blogspot.com has interesting stamps.

Poster for the 1933 Spartakiad in Moscow. "KSI" is the Russian acronym for the Red Sport International; the hammer thrower is defending the Soviet Union against its enemies. Private collection.

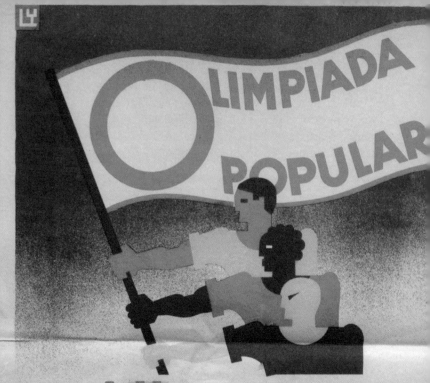

BARCELONA
22-26 DE JULIOL 1936

OLIMPIADA POPULAR, 22-26 JULIO
OLYMPIADE POPULAIRE, 22-26 JUILLE
VOLKS OLYMPIADE, 22-26 JUL
PEOPLES' OLYMPIAD, 22-26 JUL

COMITE ORGANITZADOR
RAMBLA SANTA MONICA 25
(C.A.D.C.I.)
BARCELONA

PUBLICITAT COLL · TALLERS 7 · BARCELONA

The 1936 Barcelona People's Olympics

The 1936 Olympic Summer Games belong to the darkest moments of Olympic history. The successes of black athletes like Jesse Owens were only a glimpse of hope amid shameless Nazi propaganda, condoned by the most powerful of international sports administrations. Despite strong efforts by workers' sports and Jewish organizations to boycott the games, the initiative never gathered mass support. In Spain, however, the Republican government refused to send athletes to Berlin. Instead, it decided to organize a "People's Olympics" in Barcelona, which was supposed to take place a couple of weeks before the Berlin games opened. In July 1936, six thousand athletes, many of them from workers' sports organizations, descended upon Barcelona. The day before the scheduled opening ceremony, though, General Franco started his attack on the republic, and the games had to be canceled. While most athletes traveled home, some stayed to join the international brigades.

A book released in Catalan tells the story of the Barcelona People's Olympics: *L'altra olimpiada, Barcelona '36: Esport, societat i política a Catalunya (1900–1936)* (1990), written by Carles Santacana and Xavier Pujadas. There is also a 1992 French-Spanish documentary film about the events called *Les Olympiades oubliées* (1992). For material in English, the following articles can serve as starting points: "The Movement to Boycott the Berlin Olympics of 1936" at www.ushmm.org (the website of the United States Holocaust Memorial Museum), and Ben Norman's "People's Olympiad: The True Olympic Spirit of 1936" at www.socialistportsmouth.co.uk.

Poster for the 1936 People's Olympics in Barcelona. Private collection.

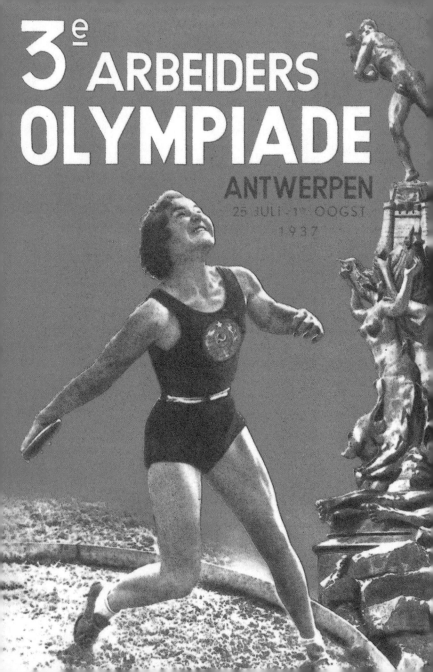

Dissolution

The international workers' movement started to crumble in the 1930s. In Germany, the Nazis prohibited all workers' sports associations after gaining power in March 1933. In Austria, the fascist regime of Chancellor Engelbert Dollfuss took the same measure only a few months later. With the centers of the workers' sports movement wiped out and a war looming, the movement struggled to survive. The Third Workers' Olympics, announced for 1937, was still being held: the winter games in Janské Lázně, Czechoslovakia, the summer games in Antwerp, Belgium. For the first time, both SASI- and RSI-affiliated athletes participated. The fascist threat had brought the two organizations closer together. It was too late, however, to gain much strength. There were only half as many participants as there had been in Austria six years earlier, and both the RSI and SASI dissolved soon thereafter. The Workers' Olympics planned for 1943 in Helsinki, Finland, never took place— nor did any other after that.

Herbert Dierker's book *Arbeitersport im Spannungsfeld der Zwanziger Jahre* (1989) recalls the conflict between SASI and the RSI. Footage from the Antwerp games can be watched in the short film *Third Workers' Olympics Antwerp 1937*, available on various video-sharing websites.

Poster for the "Third Workers' Olympics" in Antwerp, Belgium, 1937. Private collection.

DER KAMPFER

1/2 1933

Blick zum Ziel

Fighting the Fascists

When the fascist threat arose in Europe in the 1920s, workers' movement leaders explicitly linked workers' sports to antifascist resistance. SASI's president, Julius Deutsch, was one of the most prominent voices propagating such connections. Deutsch was the founder of the *Republikanische Schutzbund*, an umbrella organization for workers' militias opposing fascist paramilitaries. The February Fights of 1934 (sometimes referred to as the Austrian Civil War) was an armed uprising by antifascist workers. It left two hundred *Republikanische Schutzbund* members dead.

SASI made *Wehrsport* ("paramilitary sport" is probably the most fitting English translation, while "defense sport" is more literal) an official part of its agenda in the late 1920s. At the 1927 SASI congress in Helsinki, the following resolution was passed:

> The working class can only defend itself against fascism successfully if it creates its own protective forces. . . . As organizations fostering the physical strength of the proletariat, the task of the workers' sports organizations of all countries is to support the formation of these forces by all means. . . . In countries where such forces already exist, the workers' sports associations must cooperate with them.

The significance of workers' sports for Austria's antifascist militias can best be traced in issues of *Der Schutzbund* (1924–1931), the monthly journal of the *Republikanische Schutzbund*. German readers can also consult the article "Arbeiterbewegung und Wehrsport" by Michael Scholing and Eva Nierhoff, in *Arbeiterkultur und Arbeitersport*, edited by Hans Joachim Teichler (1985).

Cover of "The Fighter," no. 1–2, 1933, an Austrian journal for workers' sports and antifascism. "Blick zum Ziel" roughly means "Eyes set on the goal." Private collection.

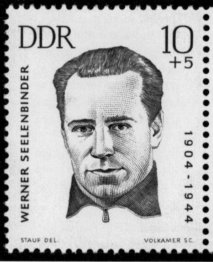

Werner Seelenbinder stamp issued by the Deutsche Post of the German Democratic Republic (GDR, commonly known as East Germany), 1963. Private collection.

Resistance

The hopes for the workers' sports movement to help repel the fascists were disappointed. Many German and Austrian worker athletes went into exile; others joined the underground resistance. One of them, Wilhelm Braun, wrote in his memoirs: "Not the SPD [the German Social Democrats] but we workers' athletes did the illegal work; and after us, not much was achieved."

The most famous athlete-turned-resistance fighter was the wrestler Werner Seelenbinder, who had been banned from wrestling for eighteen months after refusing to perform a Hitler salute as the German 1933 light heavyweight champion. He intended to repeat the protest at the 1936 Olympics in Berlin but only came in fourth. After joining the underground resistance, Seelenbinder was executed in October 1944. The former *Rotsport* chairman Ernst Grube was executed by the Nazis as well. In Italy, the famed cyclist Gino Bartali, a winner of both the Giro d'Italia and the Tour de France, was involved in the resistance against Mussolini.

A report by an official of the Nazi-loyal German Cyclists Association suggests how worker athletes continued to organize in the 1930s: "Very few people from former clubs like *Solidarität* are joining us. I have seen them gather in groups and cycle together to quiet places. I have reason to believe that they exercise a secret intelligence service and have informed the Gestapo."

There are books in German and French about worker athletes in anti-Nazi resistance groups: *Deutsche Arbeitersportler gegen Faschisten und Militaristen 1929–1933* (1975) by Günther Wonneberger, *Rote Sportler im antifaschistischen Widerstand* (1978) by a GDR editorial collective, and *Les sportifs ouvriers allemands face au nazisme* (2010) by Guillaume Robin. The novel *Der Stärkere* (1962) by Walter Radetz and Friedel Schirm's biographical sketch *33 Monate—Erinnerungen an Werner Seelenbinder* (1984) are dedicated to Seelenbinder's memory. Gino Bartali is portrayed in the book *Road to Valour* (2012), written by Aili and Andres McConnon.

Crest of the Hapoel sport organization. From www.hpt.co.il.

Legacy

Even as some workers' sports organizations were reestablished after the war, workers' sport as an influential mass movement was history. Its infrastructure was destroyed and its historical moment lost. Class structures and political priorities changed in postwar Europe. SASI's successor, the *Confédération Sportive Internationale Travailliste et Amateur* (CSIT) never developed a strong political profile. In 1986, it was officially recognized by the International Olympic Committee, contradicting some of SASI's most central ideals.

Among the national workers' sports associations that had been united in SASI, it was—perhaps in a ghastly twist of irony—the branch founded in the British Mandate of Palestine that proved most resilient. While millions of Jews were killed on the European continent, the Jewish workers' sports organization Hapoel, founded in 1926, continued to thrive. While Hapoel's role in the formation of the Israeli nation state has been the subject of strong criticism from anti-colonial perspectives, Hapoel clubs remain centers of left-liberal politics in Israel, especially compared to the mainstream Maccabi and the right-wing Beitar associations.

For Hapoel's history, see Haim Kaufmann's article "Maccabi versus Hapoel: The Political Divide That Developed in Sports in Eretz Israel, 1926–1935," in *Sport, Politics and Society in the Land of Israel: Past and Present* (2009), edited by Yair Galily and Amir Ben-Porat. For general information see www.hapoel.org.il.

RACISM & SPORT

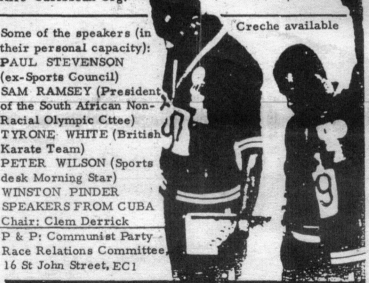

All sports enthusiasts welcome

SUNDAY, JANUARY 29TH
11.30 am - 4.30 pm

COUNTY HALL, LONDON
(Waterloo Station)

National Discussion
Conference sponsored
by the Communist Party
Afro-Caribbean Org.

Indian Workers Association
(GB), Prem Singh and the
Kashmiri Workers

Creche available

Some of the speakers (in
their personal capacity):
PAUL STEVENSON
(ex-Sports Council)
SAM RAMSEY (President
of the South African Non-
Racial Olympic Cttee)
TYRONE WHITE (British
Karate Team)
PETER WILSON (Sports
desk Morning Star)
WINSTON PINDER
SPEAKERS FROM CUBA
Chair: Clem Derrick

P & P: Communist Party
Race Relations Committee,
16 St John Street, EC1

Fair Play for the People: Sports and Civil Rights (1946–1989)

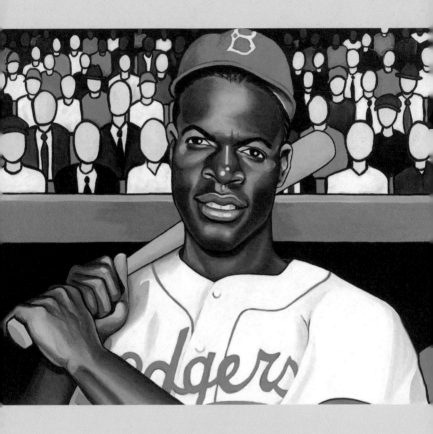

Painting by Dan Nolan (www.dannolan.com).

Jackie Robinson

After World War II, at the dawn of worldwide civil rights struggles, sports became an increasingly important political terrain. One of the most significant events was the breaking of the race barrier in U.S. Major League Baseball, when Jackie Robinson started for the Brooklyn Dodgers in 1947. Robinson's significance for the civil rights struggle cannot be overstated. Not only did he serve as an important symbol but he also was a sharp critic of insufficient civil rights policies. The determination and grace with which he handled abuse on and off the field earned him an iconic status in the history of African-Americans and other minorities. Many prominent athletes taking a stance for civil rights followed in his footsteps, among them the track and field athlete Wilma Rudolph, the golfer Charlie Sifford, the football player Jim Brown, the basketball player Bill Russell, and the tennis player Arthur Ashe.

Among the numerous books about Robinson, Arnold Rampersad's *Jackie Robinson: A Biography* (1997) is the most renowned. An interesting publication is *First Class Citizenship: The Civil Rights Letters of Jackie Robinson* (2007). A general study of integration in Major League Baseball and its impact on African-American and Latino communities has been presented by Rob Ruck in *Raceball: How the Major Leagues Colonized the Black and Latin Game* (2012). *The Jackie Robinson Story* (1950) is a cinematic—and very patriotic—representation of Robinson's career with Robinson playing himself. The film *42* (2013), named after Robinson's jersey number (today retired in all of Major League Baseball), is a recent Hollywood biopic about his life. Most of the other mentioned athletes have published autobiographies: Bill Russell, *Go Up for Glory* (1966); Jim Brown, *Out of Bounds* (1989); Charlie Sifford, *Just Let Me Play* (1992); and Arthur Ashe, *Days of Grace* (1993).

Roberto Clemente

was simply a man, a man who strove to achieve his dream of peace and justice for oppressed people throughout the world."

— from Clemente's obituary in the Black Panther newspaper

Roberto Clemente

Among the politically conscious athletes following Robinson, Roberto Clemente played a particularly important role. Born in Puerto Rico in 1934, Clemente made his Major League Baseball debut for the Pittsburgh Pirates in 1955. Not only did he develop into one of the best players of the game, but he also became an outspoken advocate for equal rights and was actively engaged in solidarity work among oppressed and neglected communities. Tragically, Clemente died in a plane crash on New Year's Eve 1972, while overseeing a delivery of relief material for earthquake victims in Nicaragua—apparently, Clemente wanted to make sure the material reached people in need rather than being seized by the Somoza regime. To this day, Clemente remains a legend among baseball fans and an inspiration for politically conscious athletes around the world.

Clemente: The Passion and Grace of Baseball's Last Hero (2006) by David Maraniss is a remarkable study of the player and the person. *Clemente! The Enduring Legacy* by Kal Wagenheim is a 1973 classic. For those who prefer graphic novels, there is *21: The Story of Roberto Clemente* (2011) by Wilfred Santiago. Among the available video material, there is a 2008 production by PBS titled *Roberto Clemente*, and a 2012 ESPN miniseries called *Roberto Clemente's 3000th Hit Bat. Chasing 3000* (2010) is a charming movie based on the true story of two kids traveling across the United States to see Clemente's three thousandth hit.

Screenprint by Colin Matthes
(www.colinmatthes.com/www.justseeds.org).

PRESS BOX RED

THE STORY OF LESTER RODNEY, THE COMMUNIST WHO HELPED BREAK THE COLOR LINE IN AMERICAN SPORTS

Irwin Silber

FOREWORD BY JULES TYGIEL

Cover of the Irwin Silber book *Press Box Red*. Cover design by Action Dave Kessler. Courtesy of Temple University Press.

Lester Rodney

Journalists influenced U.S. sports, too. Perhaps the most notable example is Lester Rodney, who edited the sports page of the *Daily Worker*, the journal of the Communist Party USA, from 1936 to 1958. Rodney argued tirelessly for an end to race barriers in sports and stressed the significance that sport had in transforming social relationships. In a 2004 interview, he recalled:

> It's amazing. You go back and you read the great newspapers in the thirties, you'll find no editorials saying, "What's going on here? This is America, land of the free and people with the wrong pigmentation of skin can't play baseball?" Nothing like that. No challenges to the league, to the commissioner, to league presidents, no interviewing the managers, no talking about Satchel Paige and Josh Gibson who were obviously of superstar caliber. So it was this tremendous vacuum waiting. Anybody who became Sports Editor of the *Daily Worker* would have gone into this. It was too obvious. The *Daily Worker* had an influence far in excess of its circulation, partly because a lot of our readership was trade union people. When May Day came along, the Transport Workers Union, or Furriers District 65, would march with signs that said "End Jim Crow in Baseball."

The definitive book on Rodney is *Press Box Red: The Story of Lester Rodney, the Communist Who Helped Break the Color Line in American Sports* (2003) by Irwin Silber. There are also two interesting master's theses: Kelly E. Rusinack's *Baseball on the Radical Agenda: The Daily and Sunday Worker on Desegregating Major League Baseball, 1933–1947* (1995), and Martha McArdell Shoemaker's *Propaganda or Persuasion: The Communist Party and Its Campaign to Integrate Baseball* (1999). The cited interview with Rodney can be found at www.counterpunch.org.

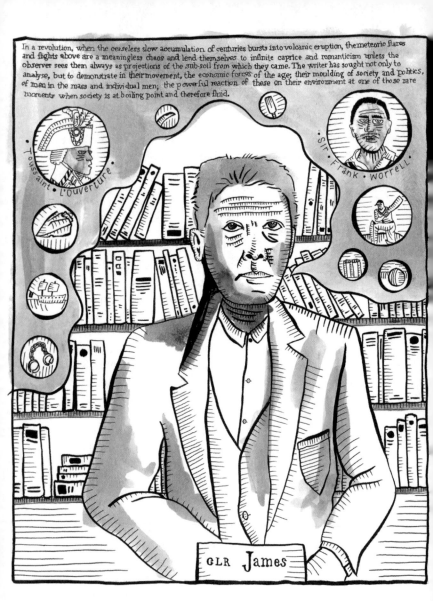

In a revolution, when the ceaseless slow accumulation of centuries bursts into volcanic eruption, the meteoric flares and flights above are a meaningless chaos and lend themselves to infinite caprice and romanticism unless the observer sees them always as projections of the sub-soil from which they came. The writer has sought not only to analyse, but to demonstrate in their movement, the economic forces of the age; their moulding of society and politics, of men in the mass and individual men; the powerful reaction of these on their environment at one of those rare moments when society is at boiling point and therefore fluid.

·Toussaint · L'Ouverture·

·Sir · Frank · Worrell·

CLR James

C.L.R. James

While some Marxist intellectuals like Terry Eagleton and Marc Perelman bash sports, other Marxist intellectuals have not only embraced sports but also actively campaigned for progressive changes. The most prominent figure is the Trinidad-born author C.L.R. James. While he was involved in a number of influential Marxist groups, the Revolutionary Socialist League and the Johnson-Forest Tendency among them, he was also a rabid cricket fan who analyzed the game in the context of colonial and racist power structures. The question "What do they know of cricket who only cricket know?" raised by C.L.R. James in his classic book *Beyond a Boundary* can serve as a guideline for all leftist sports writing.

The most important campaign James was involved in concerned the captaincy of the West Indies cricket team: when an increasing number of voices demanded a black captain, James spearheaded the movement for Frank Worrell to carry the honor. The efforts paid off when Worrell was named captain in 1960.

C.L.R. James's *Beyond a Boundary* (1963) is one of the most-referred leftist sports books of all time. James also collaborated with the West Indies cricket legend Learie Constantine in writing *Cricket and I* (1933) and *The Colour Bar* (1954). An anthology of James's writings on cricket was released in 1984 under the title *Cricket* (rereleased in 2006 as *A Majestic Innings*). The University of the West Indies houses the C.L.R. James Cricket Research Centre Library.

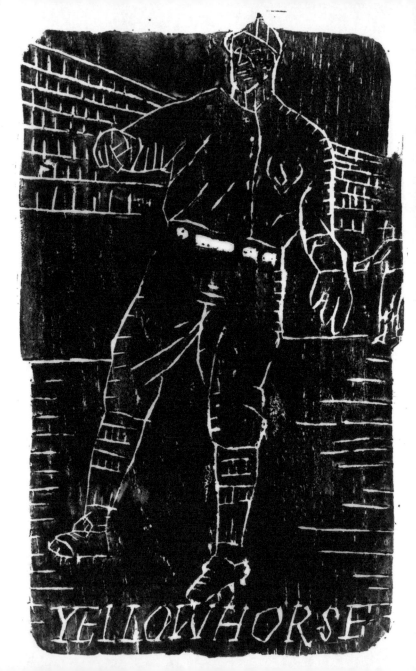

Anticolonialism

Sport has often been a force in anti-colonial and anti-imperialist struggles. A prime example is the soccer team that the Algerian *Front de Libération Nationale* (FLN) formed in Tunis in 1958. The team mainly consisted of professional players with contracts in France who had shocked their French clubs by disappearing overnight in a coordinated effort. For some years, the FLN soccer team became one of the most important international ambassadors of the Algerian liberation struggle.

Around the same time, Kwame Nkrumah, one of Africa's most prominent anticolonial leaders, named the football team of the newly independent Ghana—where he served as the first president—the Black Stars, a reference to Marcus Garvey's Black Star Line. To this day, Jamaican sprinters, Kenyan long-distance runners, and Indonesian badminton players are important athletic symbols for people in the global South. The significance of sports victories for political lightweights was summarized succinctly by the Cameroonian soccer star Roger Milla after Cameroon's upset of Argentina at the 1990 Men's Soccer World Cup. Referring to President Paul Biya, he said: "An African head of state who leaves as the victor, and who greets with a smile the defeated heads of state!… It's thanks to football that a small country could become great."

Certain sports can take on a particularly important role for the identity of oppressed nations, such as hurling and Gaelic football in Ireland or lacrosse in Native American communities. The latter also provides an example for how the colonial legacy continues to impact sports: in 2010, the Iroquois Nationals were kept from attending the Lacrosse World Championships in the UK,

Moses J. "Chief" Yellow Horse from the Pawnee nation was one of several Native Americans making an impact on Major League Baseball during its early decades. He pitched for the Pittsburgh Pirates in 1921–1922. Print by Dylan Miner (www.dylanminer.com).

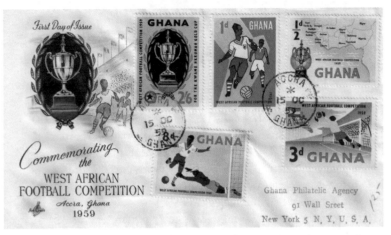

Top: Stamps from the 1959 West African Football Competition. Courtesy of Kenneth Wilburn. Bottom: Algerian commemorative stamp on the occasion of the fiftieth anniversary of the founding of the FLN soccer team. From www.thecardographer.wordpress.com, a blog accompanying the project "North to North: A Journey in Postcards from Manchester to the Maghreb" by John Perivolaris (www.johnperivolarisimages.com).

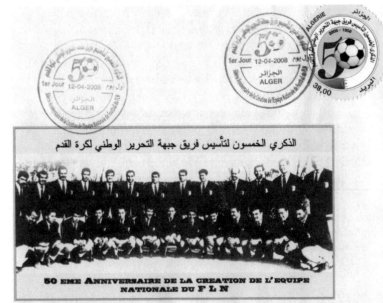

because UK authorities would not recognize their Haudenosaunee passports.

Sports clubs based on national and ethnic heritage can be vital for migrant communities, too. Türkiyemspor Berlin, founded by Turkish residents of Germany in 1978, inspired numerous Türkiyemspor clubs around the world. Another example is provided by Assyriska and Syrianska, two sports clubs based in Södertälje, Sweden, where the world's largest Assyrian community is gathered; the clubs play a crucial role for the community's status in Swedish society.

An academic study of sport's role in imperialist history is Allen Guttmann's *Games and Empires: Modern Sports and Cultural Imperialism* (1994). Jim Thorpe—who grew up in the Sac and Fox Nation in Oklahoma, excelled in various sports, and is often called the "greatest athlete of all time"—is portrayed in Kate Buford's *Native American Son: The Life and Sporting Legend of Jim Thorpe* (2010). Anthony Clavane's book *Does Your Rabbi Know You're Here? The Story of English Football's Forgotten Tribe* (2012) is a superb study of the complicated relationship between football and Judaism. The drama film *Running Brave* (1983) tells the story of the Oglala Lakota runner Billy Mills, Olympic champion in the ten thousand meter race at the 1964 Summer Games in Tokyo. *The Athlete* (2009) is an Ethiopian drama film portraying the two-time Olympic marathon winner Abebe Bikila. The documentary film *Goal Dreams* (2006) documents the Palestinian team's run for the 2006 Men's Soccer World Cup. For information about the FLN team, see Hassanin Mubarak's entry "Algeria—Equipe FLN—History and Matches" at www.rsssf.com. For the history of the Black Stars, see Kieran Dodds's article "Kwame Nkrumah's Team Are Going to the World Cup" at www.africasacountry.com.

MIROIR DU CYCLISME

MIROIR DU TOUR 6

N° 34. — 2,50 F. — ALGÉRIE : 2,95 F. — BELGIQUE : 37 F BELGES. — LUXEMBOURG : 37 F. — MAROC : 300 F MAR. — SUISSE : 2,70 F. — AUTRES PA

ANQUETI
RECORD :
4 VICTOIRE

POULIDOR

BAHAMONTES

ANQUETIL

Miroir Sprint

In Europe, the strongest tradition of leftist sports coverage exists in France, where the communist *L'Humanité* was one of the first European dailies to introduce a sports page. In 1927, the paper founded the *Grand Prix cycliste de L'Humanité*, an annual cycling competition held to this day.

After World War II, communists founded the sports magazine *Miroir Sprint*, which was published until 1971. It was successful enough to spawn several related magazines, among them *Miroir du football* (1960–1979) and *Miroir du cyclisme* (1961–1994).

Cycling has always played a special role for the French communist movement. The popularity of the Tour de France, for example, today the world's biggest cycling event, is directly related to working-class struggles. Founded in 1903, the tour only garnered a mass following in the 1930s after a long strike wave had secured a one-month summer vacation for all French workers.

To this day, some of France's most celebrated cycling journalists are communists, among them Jean-Emmanuel Ducoin. Even some of the greatest French cyclists were communist sympathizers, for example the five-time Tour de France winner Jacques Anquetil.

The anthology *Le temps du Miroir: Une autre idée du football et du journalisme* (1982) includes the most important articles of the chief editor of *Miroir du football*, François Thébaud. The website www.miroirdufootball.com has more information about the magazine. For a short article in English about the communist connections to the Tour de France, see "On Tour with the Communists!" by James Startt at www.bicycling.com. French readers are encouraged to seek out Jean-Emmanuel Ducoin's book *Tour de France, une belle histoire?* (2008).

Cover of a *Miroir du cyclisme* Tour de France 1963 special issue, celebrating the fourth victory of Jacques Anquetil. Private collection.

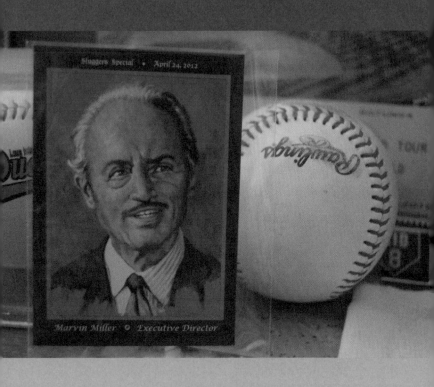

A baseball card created for an April 24, 2012, event at NYU Law honoring Marvin Miller. From www.stjclelblog.org (The Labor and Employment Law Forum, St. John's University).

Marvin Miller

While the first union for professional athletes was already founded in 1885 with the Brotherhood of Professional Baseball Players, it took until the 1960s before any athletes' union really became influential. Once again, it was in baseball, and much of it was due to the efforts of Marvin Miller. Miller, an experienced union organizer with the United Steel Workers of America, became executive director of the Major League Baseball Players Association in 1966 and negotiated the first collective bargaining agreement with team owners. The leading U.S. role in sports union organizing may be surprising, but effective soccer players' unions in Europe and Latin America—to name but one example—only emerged in the 1980s.

Sometimes, players' unions can be mistaken as inappropriate and unnecessary tools for overpaid athletes. This, however, is based on the media's distortion of the reality of professional sports. While the most powerful and rich athletes might occupy the media landscape, they make up only a tiny minority of today's professional athletes. Most of them are engaged in what has come to be called "precarious labor": they have short-term contracts, are highly dependent on their employers (in the case of migrant athletes, even their legal status depends on them), are not protected by any union, often lack health insurance, seldom have an education that allows alternatives, and are constantly threatened by injury. Among the pioneers of labor activism in sports is the baseball player Curt Flood, who challenged the control exerted by clubs over players—especially related to trades—in a highly publicized lawsuit in the early 1970s.

Marvin Miller wrote about his experiences in *A Whole Different Ball Game: The Inside Story of the Baseball Revolution* (2004). The website www.thanksmarvin.com features notes of appreciation for Miller by baseball professionals. Curt Flood's autobiography *The Way It Is* was published in 1971.

MUHAMMAD ALI

"WHY SHOULD I DROP BOMBS AND BULLETS ON BROWN PEOPLE IN VIETNAM WHILE SO-CALLED NEGRO PEOPLE IN LOUISVILLE ARE TREATED LIKE DOGS?"
—MUHAMMAD ALI 1967

CELEBRATE PEOPLES HISTORY

Muhammad Ali

There is probably no athlete who matches the political profile of Muhammad Ali. A larger-than-life figure, Ali was born as Cassius Clay in 1942, winning his first titles by that name. In 1964, he became a member of the Nation of Islam and soon changed his name to Muhammad Ali.

Ali was charismatic, eloquent, and outspoken about racial and social injustice. Things came to a head when, in 1967, he refused to be drafted into the U.S. army to serve in Vietnam. He explained his decision with statements like the following: "Why should they ask me to put on a uniform and go ten thousand miles from home and drop bombs and bullets on Brown people in Vietnam while so-called Negro people in Louisville are treated like dogs and denied simple human rights?" Ali was stripped of his world heavyweight title and banned from boxing for four years. He returned to the ring in 1970 and fought a number of classic fights before retiring in 1981.

While Ali has become less politically involved over the last decades, he remains a source of inspiration for millions of people fighting for social justice.

Among the uncountable publications about Ali, *Redemption Song: Muhammad Ali and the Spirit of the Sixties* (2000) by Mike Marqusee stands out. There are several documentary films. Among them, *The Trials of Muhammad Ali* (2013) covers Ali's decision to join the Nation of Islam and his refusal to fight in Vietnam, *When We Were Kings* (1996) is about the 1974 "Rumble in the Jungle" against George Foreman in Zaire (today the Democratic Republic of the Congo), and *Thrilla in Manila* (2008) chronicles Ali's 1975 fight against Joe Frazier in the Philippine capital.

Offset print by Colin Matthes
(www.colinmatthes.com/www.justseeds.org).

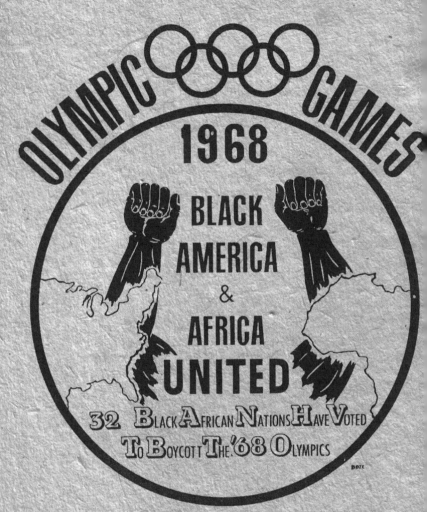

OPHR poster, 1968. From the book *The Revolt of the Black Athlete*.

The 1968 Mexico Olympics

In 1967, the sociologist Harry Edwards initiated the Olympic Project for Human Rights (OPHR). In many ways, it adapted the principles of the civil rights movement to the world of sports. Its main demands were:

1. Restoration of Muhammad Ali's title and right to box in this country.
2. Removal of the anti-semitic and anti-black personality Avery Brundage from his post as Chairman of the International Olympic Committee.
3. Curtailment of participation of all-white teams and individuals from the Union of South Africa and Southern Rhodesia in all United States and Olympic Athletic events.
4. The addition of at least two black coaches to the men's track and field coaching staff appointed to coach the 1968 United States Olympic team...
5. The appointment of at least two black people to policy making positions on the United States Olympic Committee.
6. The complete desegregation of the bigot dominated and racist New York Athletic Club.

The Mexico games were politically charged not only because of the OPHR and antiracism protests, but also because thousands of Mexicans saw them as a distracting spectacle in times of social strife. Ten days before the games' opening ceremony, more than three hundred people were shot dead during a demonstration in Mexico City; the event is known as the Massacre of Tlatelolco. The protestors received worldwide sympathy. Prominent figures such as Jean-Paul Sartre and Bertrand Russell issued statements condemning the actions of the Mexican government and called for a boycott of the games.

DE SULTNE KRÆVER REVOLUTION!

DE MÆTTE KRÆVER UNDERHOLDNING!

MEXICO 1968

VI ER MED DE SULTNE. HVEM ER *DU* MED?

Kommunistisk Ungdoms Forbund · Saxovej 19 o.g. 2 Kbh. NV

Opinions among U.S. athletes on a boycott differed. Some, such as Lew Alcindor (today better known as Kareem Abdul-Jabbar), refused to travel to Mexico. Others, such as the sprinters Tommie Smith and John Carlos, decided to do so in order to stage protests drawing attention around the world, a decision that would lead to the most iconic sports protest of all time. After Smith had taken gold and Carlos bronze in the two-hundred-meters final, both appeared for the medal ceremony without shoes to represent black poverty; Smith wore a black scarf around his neck to represent black pride, and Carlos a necklace of beads in remembrance of the victims of slavery and lynching; Carlos also had his jacket unzipped to express solidarity with all blue-collar workers in the United States. Most memorably, both lowered their heads and each raised a black-gloved fist while "The Star-Spangled Banner" was played and the Stars and Stripes were hoisted. The silver medal winner, Peter Norman of Australia, wore an OPHR button along with Smith and Carlos in solidarity.

Smith and Carlos met support from other U.S. athletes, including the men's 4x400m and the women's 4x100m relay teams as well as the all-white rowing eight, yet they were immediately banned from the Olympic village and met much hostility upon returning home. Norman was never again nominated for an Australian Olympic team, although he met the qualifying requirements several times. The three athletes remained lifelong friends; Smith and Carlos served as pallbearers at Norman's funeral in 2006.

The political climate of the late 1960s did not only lead to a critique of the civil rights situation in sports but also to a questioning of the organizational structure. The coach and sociologist Jack

"The Oppressed Demand Revolution! The Powerful Demand Entertainment? We Stand with the Oppressed. Whose Side Are You On?" Poster by Denmark's "Communist Youth Association," 1968. Courtesy of Arbejderbevægelsens Bibliotek og Arkiv, Copenhagen, Denmark (www.arbejdermuseet.dk).

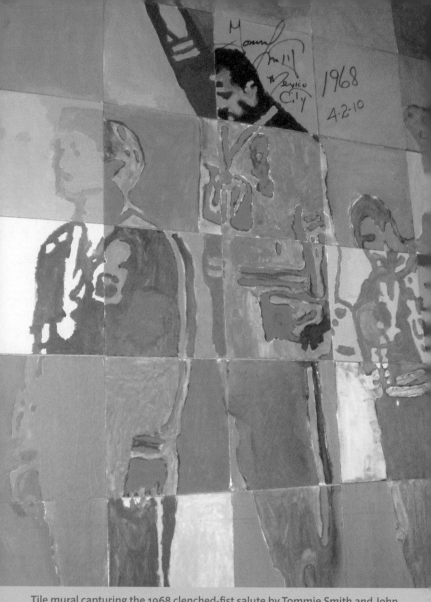

Tile mural capturing the 1968 clenched-fist salute by Tommie Smith and John Carlos, with Australian Peter Norman to the left. Artwork by Aaron De La Cruz (www.aarondelacruz.com) in collaboration with students of Frick Middle School in Oakland, California. Signed by Tommie Smith. Photograph by Jaymie Lollie.

Scott was one of the people most determined to introduce relevant changes. He believed that authoritarianism in sports was not necessary for high performance and campaigned for a democratization process. For this purpose, in 1970, he founded the Institute for the Study of Sport and Society in Oakland, California, and from 1972 to 1974 he ran the sports program at Ohio's liberal Oberlin College, putting many of his ideas into practice and hiring Tommie Smith as a coach.

Other athletes who spoke out politically in the 1960s included football players and peace activists David Meggyesy and Rick Sortun. In many ways, the era set precedents for political action in the world of sports we are witnessing to this day.

The story of the OPHR is told in the exceptional book *The Revolt of the Black Athlete* (1969), written by the project's founder Harry Edwards; the book also contains several OPHR documents and press releases. The legacy of the project is the topic of Douglas Hartmann's study *Race, Culture, and the Revolt of the Black Athlete: The 1968 Olympic Protests and Their Aftermath* (2004). The resistance movement against the Olympics in Mexico, especially its artistic elements, are captured in the article "Mexico 68: The Graphic Production of a Movement" in *Signal:01—A Journal of International Political Graphics & Culture* (2010). Tommie Smith published an autobiography titled *Silent Gesture* in 2007. John Carlos collaborated with author Dave Zirin penning *The John Carlos Story: The Sports Moment That Changed the World* (2011). Jack Scott published *Athletics for Athletes* in 1969 (a revised version appeared in 1971 as *The Athletic Revolution*). David Meggyesy formulated his take on sports and politics in *Out of Their League* (1970). The same year, Jim Bouton's legendary—and still highly recommended— inside account of Major League Baseball, *Ball Four*, was released. Notable documentary films about the era include *The Journey of the African-American Athlete* (1996), narrated by Samuel L. Jackson, *Fists of Freedom: The Story of the '68 Summer Games* (1999), *Black Power Salute* (2008), and *Salute* (2008), directed by Peter Norman's nephew Matt Norman.

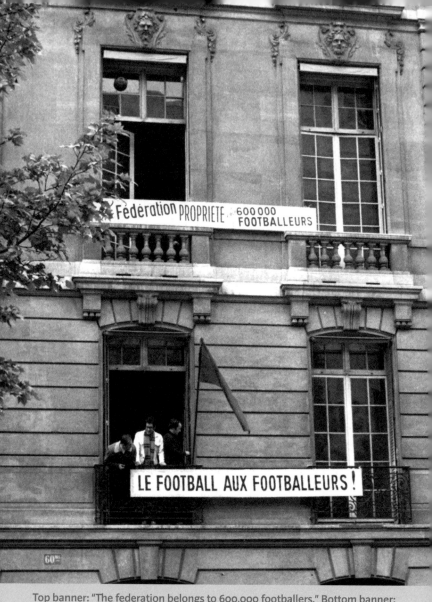

Top banner: "The federation belongs to 600,000 footballers." Bottom banner: "Football to the Footballers!" Occupation of the French Football Association headquarters in Paris, May 1968. Photograph by Jean-Claude Seine (see the photo book *Un prolétariat rêvé*, 2010, and the website www.photos-mai68.com).

Paris 1968

The wave of political and social unrest in 1968 also reached the European continent. French footballers occupied the headquarters of the French Football Association in Paris during the general strike in May, issuing a statement that included the following paragraphs:

> We footballers belonging to the various clubs in the Paris region have today decided to occupy the headquarters of the French Football Federation. Just like the workers are occupying their factories, and the students occupying their faculties. Why?
>
> *In order to give back to the 600,000 French football-ers and to their thousands of friends what belongs to them: football. Which the pontiffs of the federation have expropri-ated from them in order to serve their egotistical interests as sports profiteers…*
>
> *Free football from the tutelage of the money of the pathetic pretend-patrons* who are at the root of the decay of football.

Even if the demands were not met, another important step in political activism in sports was taken; not least with regard to the formation of soccer players unions.

Les enragés du football: L'autre Mai 68 (2008)—edited by the participants and eyewitnesses Faouzi Mahjoub, Alain Leiblang, and François-René Simon—documents the occupation of the French Football Association headquarters. The quoted statement is included in the book *Enragés and Situationists in the Occupation Movement, France, May '68* (1992) by René Viénet. It is accessible online at www.libcom.org/library/football-footballers.

we say no to apartheid

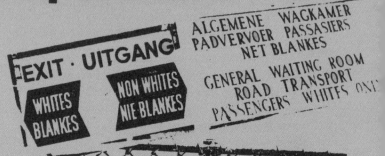

EXIT · UITGANG

WHITES BLANKES

NON WHITES NIE BLANKES

ALGEMENE WAGKAMER
PADVERVOER PASSASIERS
NET BLANKES

GENERAL WAITING ROOM
ROAD TRANSPORT
PASSENGERS WHITES ONLY

THIS PLAYGROUND EQUIPMENT IS RESERVED EXCLUSIVELY FOR USE
BY CHILDREN WHO ARE MEMBERS OF THE WHITE GROUP.
NO DOGS ALLOWED IN THIS AREA.

HIERDIE SPEELTERREINTOERUSTING IS UITGEHOU VIR DIE UITSLUITLIKE
GEBRUIK VAN KINDERS WAT LEDE VAN DIE BLANKEGROEP IS.
GEEN HONDE WORD BINNE HIERDIE GEBIED TOEGELAAT NIE.

will you say no to apartheid?

DO NOT PLAY WITH APARTHEID
CAMPAIGN FOR TOTAL ELIMINATION OF APARTHEID IN SOUTH AFRICAN SPORT

Anti-Apartheid

The longest-lasting campaign in sports with roots in the 1968 struggles was the sports boycott of the South African apartheid state. A central organization in this effort was the South African Non-Racial Olympic Committee (SAN-ROC), founded by the South African poet Dennis Brutus in 1962. While South Africa was excluded from the Olympic movement in 1970 (after its delegations had already been banned from attending the 1964 and 1968 Olympics), all-white South African rugby and cricket teams where still invited to tour the UK, Ireland, Australia, New Zealand, and the United States. In all of these countries, and beyond, activist groups began to organize massive protests.

The first broad popular campaign targeted a 1969 Great Britain and Ireland tour by the South African rugby team, the Springboks. The same year, the organization Halt All Racist Tours (HART) was founded in New Zealand. One year later, the Stop the Seventy Tour campaign succeeded in stopping South Africa's cricket team, the Proteas, from visiting Great Britain. A leading voice in the campaign was the South African-raised Peter Hain, today a British Labour MP. In 1971, the sisters Meredith and Verity Burgmann—today well-known activists—achieved nationwide fame in Australia when they ran on the field of the Sydney Cricket Ground to interrupt an Australia vs. South Africa rugby game. The international network Stop All Racist Tours (SART) was founded in 1973 and protests continued throughout the decade, culminating in week-long battles between protestors and police during a Springboks tour of New Zealand in 1981, when more than two thousand protestors were arrested and the game in Hamilton

Image from the pamphlet *South Africa's Apartheid Rugby: The Facts*, published by SAN-ROC and SART, 1981. Courtesy of the African Activist Archive Project at Michigan State University (www.africanactivist.msu.edu).

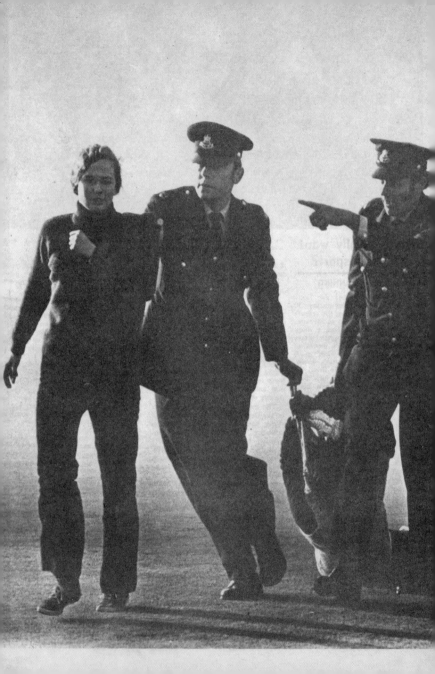

was canceled after protestors had occupied the field. The same year, the U.S. coalition Stop the Apartheid Rugby Tour opposed a Springboks tour of the country. Among the athletes who took a strong stand against apartheid until the regime was changed in 1994 were the Swedish high jumper Patrik Sjöberg, the British boxer Lloyd Honeyghan, and the Dutch football player Ruud Gullit.

An overview of anti-apartheid protests in sports is provided by Richard Lapchick's *The Politics of Race and International Sport* (1975). Peter Hain documented the Stop the Seventy Tour campaign in *Don't Play with Apartheid: Background to the Stop the Seventy Tour Campaign* (1971). *Political Football: The Springbok Tour of Australia* (1971) by Stewart Harris, and *Dancing on Our Bones: New Zealand, South Africa, Rugby and Racism* (1999) by Trevor Richards, cofounder and longtime chairman of HART, tell the stories of protests in Oceania. There are also good documentary films: *Political Football* (2005) portrays Australian rugby players who refused to play the Springboks, while *Patu!* (1983) includes extensive footage of the 1981 anti-tour protests in New Zealand. *Fair Play: 1958–1981* (2010), the fourth episode of the award-winning BBC series *Have You Heard from Johannesburg: Seven Stories of the Global Anti-Apartheid Movement* covers a variety of campaigns and actions in sports.

Verity Burgmann (facing the camera) and Meredith Burgmann (dragged by the officers) during their interruption of a Springboks game at the Sydney Cricket Ground in July 1971. From *The Bulletin*, July 17, 1971.
Overleaf: Poster from the Stop the Seventy Tour campaign in Great Britain. Courtesy of the Anti-Apartheid Movement Archives (www.aamarchives.org).
Poster announcing a protest against the Springbok tour of New Zealand in 1981. Courtesy of the Christchurch City Libraries.

If you could see their national sport you might be less keen to see their cricket.

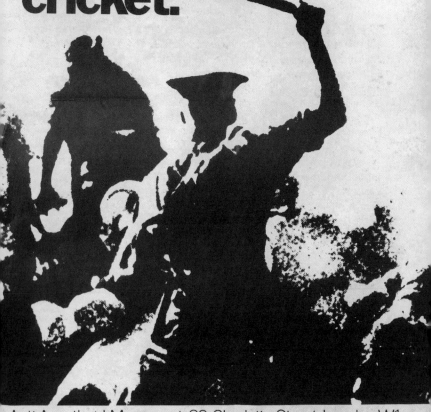

Anti-Apartheid Movement, 89 Charlotte Street, London W.1.

FIGHT APARTHEID
STOP THE TOUR
MOBILISE
MAY 1st

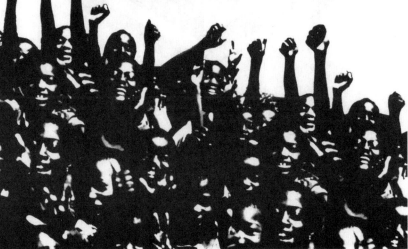

march from: Lancaster Park
Sydenham Park
Merivale Mall
Riccarton Mall

ENQUIRIES
640 65

MEET 7·00 PM
+ MARCH TO
SQUARE.

Published by HART:NZAAM P.O.Box 9204 Wellington

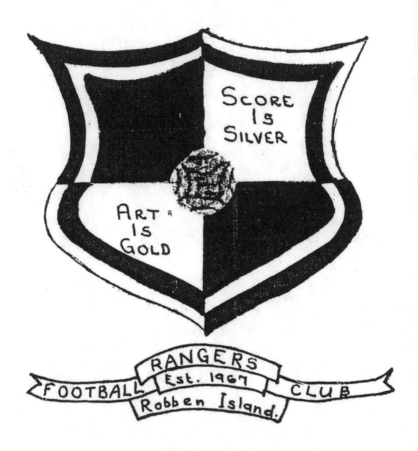

Crest of the Rangers Football Club, one of the sports clubs established by political prisoners on Robben Island. Courtesy of Chuck Korr, the author of *More Than Just a Game: Soccer vs. Apartheid* (2008).

Robben Island

Sport provides people in difficult circumstances with purpose, direction, and passion. This is also true for political radicals. Among the best examples are the sporting events organized by inmates of the infamous Robben Island prison in South Africa. In 1966, political prisoners founded the Makana Football Association; twenty-five years of various sporting leagues and tournaments followed. Ex-Robben Island prisoners have described sport as "a way of building character, of teaching proper values, of finding ways to persevere in the worst of conditions," praising it "for keeping our spirits high and for cultivating, encouraging, and maintaining the good and healthy relations among the residents of this place." Sadly, Nelson Mandela and other inmates separated from the general population were barred from playing.

In many troubled regions, these qualities have allowed sports to mitigate communal strife. The boxing clubs of Northern Ireland, in which Catholics and Protestants competed side by side even during the harshest periods of sectarian strife, are one example; others are provided by sports clubs and projects in Israel/Palestine, Ex-Yugoslavia, and Central Asia.

The history of sports on Robben Island has been documented in the splendid book *More Than Just a Game: Soccer vs. Apartheid* (2008), authored by Chuck Korr and Marvin Close (the quotes above are taken from its pages). In 2007, a feature film was released under the same name. *Pelada* (2010) is an intriguing documentary film following U.S. soccer enthusiasts playing pick-up games in twenty-five countries. *Rising from Ashes* (2012) documents the formation of a national cycling team in Rwanda in the wake of the 1994 atrocities. The sociologist John Sugden has written on boxing in Northern Ireland, for example in his book *Boxing and Society: An International Analysis* (1996). Websites of socially oriented sports projects include www.athletesunitedforpeace.org, www.playthegame.org, and www.streetfootballworld.org.

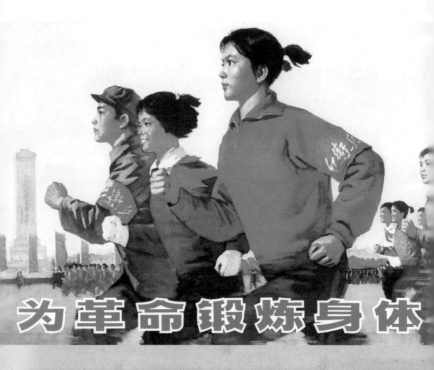

为革命锻炼身体

Proletarier aller Länder und unterdrückte Völker, vereinigt Euch!

ROTER MORGEN

Zentralorgan der KPD / Marxisten-Leninisten

Nr. 17 28. August 1972 6. Jahrgang 50 Pfennig

AUFRUF
des Zentralkomitees der KPD/ML

ZUR OLYMPIADE

Es lebe das rote CHINA

Bürgerliche Propaganda-Hetze gegen China: Beweis der Schwäche des Imperialismus. Beweis für das Erstarken des Hauptbollwerks der Weltrevolution: Der Volksrepublik China

Im vorigen ROTEN MORGEN entlarvten wir bereits die ungeheuerliche Hetze der modernen Revisionisten gegen das rote China. "Mao ruft kalten Krieger zu sich" krakeelte die UZ der D"K"P anläßlich des Schröderbesuchs in China. Inzwischen hat auch die gesamte bürgerliche Propagandamaschine eine breite Kampagne zur Diffamierung der VR China gestartet. Diese Kampagne ist sehr lehrreich. Sie zeigt die ganze Schwäche und Zerrissenheit, die ganze Ausweglosigkeit der Bourgeoisie und der imperialistischen Mächte, angesichts der weltweiten revolutionären Bewegung. Die bürgerliche Hetze zeigt: Das Bollwerk des Sozialismus, das rote China erstarkt immer weiter.

1967 standen 15 sowjetische Divisionen an der nordchinesischen Grenze. Heute sind dort bereits 45 Divisionen aufmarschiert. Die Spatzen pfeifen es von den Dächern: Die sowjetischen Sozialimperialisten bereiten den Aggressionskrieg gegen das rote China vor.

Im Osten wollen sie Krieg, an der Westflanke des Zarenreichs wünschen sie Ruhe — Friedhofsruhe! Diese Friedhofsruhe versprechen sich die Breshnew-Banditen durch das Komplott von Washington und Bonn über Europa. Diese Politik: "Friedhofsruhe in Europa — Krieg in Asien" wird durch China's revolutionäre Außenpolitik durchkreuzt.

Der westdeutsche Imperialismus kennt die Aggressionsinteressen der Kremlzaren. Er kennt die Schwäche des Sozialimperialismus, der mit Krieg und faschistischem Terror den Untergang der Zarenherrschaft verhindern will. Diese Schwäche nutzen die Bonner Großmachtsplaner aus. Sie bieten sich Moskau als Partner an, der mit ihnen gemeinsam die Friedhofsruhe in Europa durchsetzt. Aber der Westdeutsche Revanchismus fordert von Moskau seinen Teil. Stück um Stück erhält er Zugeständnisse, wird ihm die Souveränität der Staaten Osteuropas von den Kremlzaren zugeschachert. Moskau wünscht die "Konferenz für

State Socialism

Once the state socialist countries under the leadership of the Soviet Union had decided to join the Olympic movement in 1952, their athletic achievements soon became a matter of high prestige. Victories at Olympic Games and other international sporting events were considered proof for the superiority of the socialist system. Apart from the Soviet Union, it was particularly East Germany that produced world-class athletes. In Cuba, too, the international success of boxers, track and field athletes, and baseball players became an important element of national pride.

The Sino-Soviet split, dividing the global socialist camp in the 1960s, was strongly reflected in sports. China and its allies, such as Albania, did not follow the Soviet Union's stress on high performance. This was ideologically justified by prioritizing mass sport over the records of elite athletes, very much in the tradition of the workers' sports movement. Perhaps ironically, China turned into a medal-producing powerhouse as soon as Soviet sports propaganda ended with the Soviet Union's collapse in 1991.

The best overview of the role of sports in state socialist countries is provided by James Riordan's study *Sport, Politics, and Communism* (1991). To get a taste of state socialist sports rhetoric, the article "Fidel Castro on Sports in Revolutionary Cuba" can be consulted at www.marxistleninist.wordpress.com.

Top: "Exercising for the Revolution." Chinese propaganda poster, 1969. Courtesy of HKS 13. Bottom: The German Maoist journal "Red Morning" issues a protest call against the 1972 Olympics in Munich. Private collection.

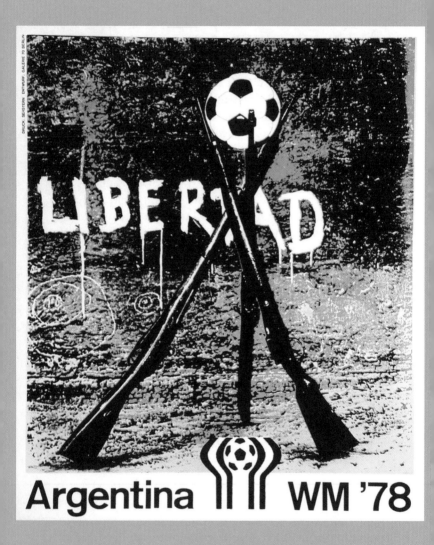

Poster protesting the 1978 Men's Soccer World Cup. Courtesy of HKS 13.

Soccer World Cups I

Next to the Olympic Summer Games, the Men's Soccer World Cup is the planet's biggest sporting event. It is therefore not surprising that it is also a site of fierce, if often hidden, political contest. The 1934 World Cup in Italy, for example, was used as a showcase for Mussolini's fascist regime.

The first time a broad protest movement against a World Cup emerged was on the occasion of the 1978 tournament played in Argentina under a military dictatorship. There had been local protests by radical leftists in West Germany four years earlier as well, but the protests against the Argentinean cup were global and involved broader sections of society. Boycott movements never had a realistic chance, but there were individual acts of resistance, most famously the refusal by Argentina's coach César Luis Menotti to shake the hand of junta leader Jorge Videla after Argentina's final victory.

In the 2000s, protests against the Men's World Cup have intensified (see "Soccer World Cups II," page 145).

German resistance to the 1974 World Cup is chronicled in the online documentation *K-Gruppen, DKP und der (Arbeiter-)Sport*, compiled by Dietmar Kesten and accessible at www.mao-projekt.de. Informative articles about the 1978 World Cup are "June 25—The Shame of Argentina '78" by J-Rock at www.onthisfootballday.com, and "Operation Cóndor Played Out in the 1978 World Cup" by Vicky Pelaez at www.amateursport.wordpress.com.

Cover of the "Official Journal of the Corinthians Sports Club," June 1984. The headline reads: "We've lost this gesture. Have we lost democracy, too?" It relates to Sócrates leaving Brazil to play in Italy following the military regime's refusal to allow direct presidential elections. Private collection.

Democracia Corinthiana

The Democracia Corinthiana movement, which lasted from 1982 to 1984, must perhaps count as the boldest experiment of political activism in the world of professional sports.

The São Paulo sports club Corinthians was founded in 1910. It is the city's second main club besides São Paulo FC. The Democracia Corinthiana movement combined two goals: to democratize the game of football by involving players in all decisions from training sessions to transfers, and to challenge the military regime with a strong pro-democracy message. The movement was started by players on the Corinthians team and found its most famous voice in the charismatic and elegant star player Sócrates. It ended when Sócrates left Brazil in 1984 in frustration over the stalled democratization process, playing for one year in Italy with Fiorentina. When the military regime was replaced by civilian rule in 1985, Sócrates returned.

Sócrates died in 2011. He remains a hero to political football supporters around the world, with Democracia Corinthiana serving as an example of the progressive potential that committed collective action in sports has.

There is not much English-language material available on Democracia Corinthiana, but those with Portuguese language skills—or the determination to pick them up—will be delighted by José Paulo Florenzano's study *A Democracia Corinthiana: Práticas de liberdade no futebol brasileiro* (2009). Sócrates himself has provided the account *Democracia corintiana: a utopia em jogo* (2002, with Ricardo Gozzi). For those who prefer visual recollections, there is the documentary film *Ser Campeão é Detalhe: Democracia Corinthiana* (2011).

Emblem used by antifascist football fans at Chelsea in the 1980s. Similar emblems could be found at numerous British football grounds at the time. Private collection.

Antifa on the Terraces

In the 1980s, right-wing forces in Britain began to intensify their recruitment efforts on football grounds. A leading force was the National Front. The journal of its youth federation, *Bulldog*, had a column titled "On the Football Front." The stadiums of clubs like Millwall, West Ham, and Chelsea became notorious stomping grounds for right-wing extremists.

At first, activists began confronting National Front agitators, often outside of the stadiums. It soon became clear, however, that the only effective means to fight them was to get supporters on the terraces involved, especially those with strong roots in the local fan community. This approach proved successful. By the end of the 1990s, the fascists had largely retreated.

The struggle set a precedent for many antifascist activities in soccer, which unfortunately remain necessary to this day. It also laid the foundation for anti-discrimination campaigns such as Football Unites—Racism Divides, Show Racism the Red Card, and Kick It Out.

While it doesn't concentrate on the activities in and around football grounds, the book *Beating the Fascists: The Untold Story of Anti-Fascist Action* (2010) by Sean Birchall provides a good sense of the political climate in Britain at the time. David Eimer's article "The Hard Left," published in the *Guardian* on November 25, 1994, focuses specifically on the football-related struggles; it is archived online at www.redactionarchive.org. More information about the mentioned campaigns can be found at www.furd.org (Football Unites, Racism Divides), www.srtrc.org (Show Racism the Red Card), and www.kickitout.org.

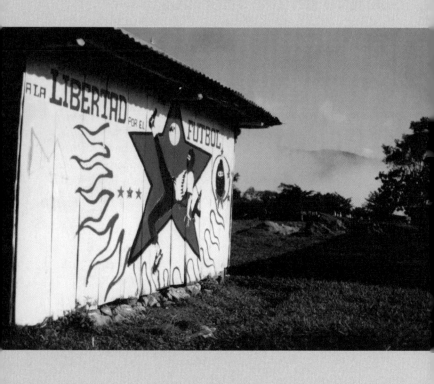

Banksy mural in Chiapas, Mexico. Photograph by R.S. Grove.

From the Ground Up: Grassroots Organizing in Sports (1990–present)

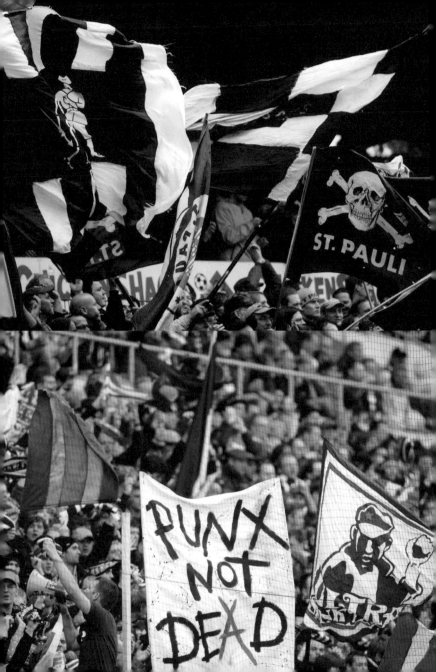

Supporters Culture

Since the late 1980s, supporters have increasingly become involved in sports administration, trying to democratize it, to equip it with progressive values, and to counteract commercialization. This has probably been most pronounced in European soccer.

A crucial factor in this development was the emergence of a progressive supporters culture at the Hamburg soccer club FC St. Pauli in the mid–1980s. When squatters from the nearby Hafenstraße started attending the games, they brought their aesthetics and politics with them and began to reshape German soccer supporters culture. Numerous antifascist fan clubs were formed, many of which, in 1993, united in the *Bündnis antifaschistischer Fußballfans* (Association of Antifascist Soccer Fans), soon renamed *Bündnis aktiver Fußballfans* and commonly known by its acronym BAFF. BAFF inspired similar projects in other countries, organizations like *F_in: Frauen im Fußball* ("Women in Soccer") and Queer Football Fanclubs, and international networks such as Alerta and Ultra Rebels or the more institutional Football Against Racism in Europe (FARE).

The phenomenon of a progressive supporters culture is not reduced to soccer, however. HC Ambri-Piotta, a Swiss ice hockey club, is well known for its left-wing fans. In Greece, Radical Fans United brings together fans from all sorts of sports.

All of these projects address racism, sexism, and homophobia in sports, keep stadiums from turning into mere consumer temples, and encourage supporters to become actively involved in their clubs.

Active supporters culture is a key factor for grassroots democracy and healthy community ties in sports. It is a movement providing plenty of hope.

Impressions from St. Pauli's Millerntor Stadium. Photographs by Selim Sudheimer.

Clockwise from top left: Sticker of Radical Fans United, Greece. Logo of Front Commun, a left-wing supporter group of Montréal FC. Logo of the antifascist soccer supporters network Alerta. Logo of the SV Babelsberg 03 supporters club Filmstadt Inferno 99—Ultras Babelsberg with an image of Karl Liebknecht. All private collection.

Peter and David Kennedy have edited the academic volume *Football Supporters and the Commercialisation of Football: Comparative Responses across Europe* (2012), which contains interesting articles but is prohibitively expensive. More affordable are critiques of soccer's development from the perspective of critical fans. Among recommended titles are John Reid's *Reclaim the Game* (2005; orig. 1992), David Conn's *The Beautiful Game? Searching for the Soul of Football* (2005), and Matthew Bazell's *Theatre of Silence: The Lost Soul of Football* (2008).

There is now also a book in English on the St. Pauli phenomenon, namely Nick Davidson's *Pirates, Punks & Politics—FC St. Pauli: Falling in Love with a Radical Football Club* (2014). Interesting articles on St. Pauli in English are available at www.playleftwing.org. Among the innumerable German publications about the club, the *St. Pauli Vereinsenzyklopädie* (2008), edited by Ronny Galczynski and Bernd Carstensen, remains a good starting point.

BAFF has published two books: *Ballbesitz ist Diebstahl* (2003) and *Die 100 'schönsten' Schikanen gegen Fußballfans* (2004). Gerd Dembowski, a longtime BAFF spokesperson, is a prolific author. One of his most original publications is *Fußball vs. Countrymusik* (2007). For music fans, there is a BAFF sampler titled *Music for the Terraces* (2003), and a monumental 5-CD box set dedicated to FC St. Pauli, titled *St. Pauli Einhundert*, which was released on the occasion of the club's one-hundredth anniversary in 2010.

For the supporters culture of HC Ambri-Piotta, see the article "What Does Geronimo Have to Do with Ice Hockey? An Excursion to a Swiss Valley" at www.alpineanarchist.org.

The website of the St. Pauli Fanladen, an invaluable source for all things St. Pauli, is www.stpauli-fanladen.de. BAFF's online presence is www.aktive-fans. Other useful websites are www.f-in.org (*Frauen im Fußball*), www.queerfootballfanclubs.com, www.alerta-network.org, www.rebelultras.com, www.farenet.org, and www.rfu.blogspot.com (Radical Fans United).

Impressions from the stands at FC United of Manchester games.
Photographs by Mark Van Spall (top) and Mick Dean (bottom).

Community Sports Clubs

The founding of community sports clubs is one of the most inspiring expressions of active supporters culture. When more and more clubs were taken over by magnates and corporations, some supporter groups decided to simply found their own clubs instead. The most famous example for this is FC United of Manchester, formed after Manchester United FC was bought by the U.S. billionaire Malcolm Glazer. Other examples include the AFC Wimbledon in England, Austria Salzburg in Austria, and Hapoel Katamon Jerusalem in Israel. Some professional clubs have also been taken over by their fans as cooperatives. Among them are Stirling Albion in Scotland, Wrexham FC in Wales, and Bohemians 1905 in the Czech Republic. The American football team Green Bay Packers is the only major fan-owned professional sports team in the United States. There are also sports clubs still based on the principles of the workers' sports movement, focusing on communal values and social and physical learning rather than on "athletic success." These clubs range from explicitly socialist ones (Republica Internationale FC in England or Proletären FF in Sweden) to antifascist ones (Roter Stern Leipzig in Germany or FC Vova in Lithuania) to autonomous/anarchist ones (Creu Negra Duatlètica in Catalonia or Autônomos & Autônomas FC in Brazil).

One of the best known community sports clubs is the Easton Cowboys and Cowgirls in Bristol. Founded in July 1992 by "twenty punks, anarchists, hippies, asylum seekers and local kids," the club now has more than ten teams playing in three sports (soccer, cricket, and netball). In an essay retracing the club's history, founding member Roger Wilson shares the following reflections:

> My key point is here that some fundamental ideas that make up the basis of anarchist theory (autonomy, democracy, inclusivity and internationalism) were tested out in a new

WANTED

Ffi phone:
One More Mare
07772542292
or Rosie Wren
07773043524

Ffi email:
lin_heal@yahoo.
co.uk or
welshberd@yaho
o.com

Netball players to join
a friendly local team:
Easton Cowgirls!

REWARD

Improved social life!
Get fitter!
Join an alternative-thinking
sports club.

www.eastoncowboys.org

Easton Cowgirls netball team recruitment poster, 2011. Design by Lin Heal.
Courtesy of Easton Cowboys and Cowgirls Sports and Social Club.

arena, the sports club, which had been pretty much ignored by the "revolutionary" movement. So whilst Political communities struggled with trying to get people to implement these ideas in their opposite, the political Community (mostly without much success), i.e. informal projects such as the Easton Cowboys Sports and Social Club, were able to actually test these things in practice in a much more pragmatic sense. After all, arming any community with actual experience of these four ideas is always useful even if it is not overtly Political. In fact I would argue that it is precisely because it wasn't seen as being Political that these ideas were able to flourish and be tested in the "real world."

Football allowed the crossing of certain barriers (class, race and nation) because of its apparent neutrality and popularity. The oppositional political and cultural ideas of the 1980s were translated into a new social form in the 1990s allowing them to expand beyond the limitations of the "anarchist ghetto" of formal Political organizations or exclusionary sub-culture. This symbiotic relationship is the key to understanding the success of the "expanded sports club"; soccer the lubricant, progressive ideas the engine.

Soccer is of course far from the only sport played in community sports clubs. In St. Petersburg, Russia, a lively alternative sports culture has developed that includes rugby, running, and powerlifting events. In the United States there is a network of community softball clubs, in which the Oregon Avenue Octopi of Philadelphia has played a pioneering role. In their 2011 "Yearbook," also available as a zine, team member Sarah summarizes experiences that reflect those of many community sports clubs' members:

> The great thing about being on a team is that there is less pressure on any one individual. I always felt I had to be

RADICAL NERD PUNK ROCK
SOFTBALL
RECRUITMENT

JOIN THE OCTOPI
LOCATION: BROAD AND OREGON
TIME: 10AM EVERY SUNDAY
NO REGISTRATION REQUIRED
JUST SHOW UP AND PLAY
BRING BEER IF YOU WANT

THE MORE THE MERRIER
FOR MORE INFORMATION EMAIL JAMES AT JGENERIC@GMAIL.COM

Oregon Avenue Octopi softball recruitment poster, 2011. Design by Drew LeVan (www.levandesigns.com). Courtesy of Oregon Avenue Octopi.

responsible in group projects, and never had anyone that was very reliable in my life, so it is relieving to know that people will back you up. In all of my political work we'd always talk about building community, but then we'd go back to the office and sit on our computers for twelve hours a day. We'd try to form functional groups, but without any basis for trust they would fall apart, or dissolve after one campaign. Building a more sustainable community means forming relationships with people, before anything else. Not forming relationships to meet an end. This is what the softball team does and we have a fucking great time while doing it.

Community sports clubs bring principles of self-management, autonomy, and DIY to the world of sports, where they are as important as anywhere.

For a thorough investigation of corporate club ownership, see Dave Zirin's book *Bad Sports: How Owners Are Ruining the Games We Love* (2010). The Stuart Saint article "Fan Controlled Football Clubs" in the anarchist magazine *Organise!* (no. 71, Winter 2008) sketches the beginnings of the new community sports clubs movement in the UK. The history of the Easton Cowboys and Cowgirls has been documented by Will Simpson and Malcolm McMahon in *Freedom Through Football: The Story of the Easton Cowboys and Cowgirls* (2012). The cited essay by Roger Wilson was published in the book *Soccer vs. the State* (see page 17). The *Oregon Avenue Octopi 2011 Yearbook* can be ordered from AK Press. The websites of the mentioned clubs are www.fc-utd.co.uk (FC United of Manchester), www.afcwimbledon.co.uk, www.austria-salzburg.at, www.katamon.co.il, www.stirlingalbionfc.co.uk, www.wrexhamafc.co.uk, www.bohemians.cz, www.packers.com, www.republica-i.co.uk, www.proletarenff.se, www.rotersternleipzig.de, www.fcvova.lt,www.creunegraduatletica.blog.cat,www.autonomosfc.com.br, www.eastoncowboys.org.uk, and www.octopisoftball.tumblr.com.

Schon 390 Tage Derbysieger!

ÜBERSTEIGER 106

1,60 €
12.03.2012

Gigantisches nicht gehorchendes Bullenwachen-Hetzblatt rund um den FC St. Pauli

ICH MUSS LEIDER
DRAUSSEN BLEIBEN

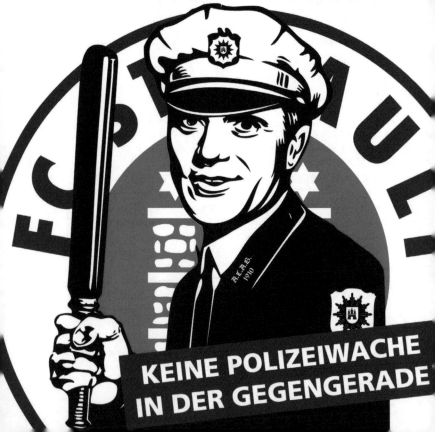

KEINE POLIZEIWACHE
IN DER GEGENGERADE

Zines

An important part of community sports culture, reflecting the ever-present DIY influence, are the numerous zines that have served as a central means of communication and debate. Deriving their name from (flashier) "magazines," zines are self-produced periodicals that include everything from personal rants to thorough social analysis. In the world of sports, they have been used by fans to spread their messages, by activists to mobilize campaigns, and by community clubs to keep their members informed. One of the best things about it all is that while zine culture overall suffers from the competition of online blogs, sports zines have a guaranteed hard-copy readership in the stands.

Besides *Übersteiger* (www.uebersteiger.de), some of the most legendary sports zines are *TÁL* at Celtic Glasgow (www.talfanzine.com) and *Zisk*, "The Baseball Magazine for People Who Hate Baseball Magazines" (www.ziskmagazine.com). The *Zisk* editors have also published a book with selected articles (and a stunning cover), titled *Fan Interference: A Collection of Baseball Rants and Reflections* (2013). *High & Outside*, based on the personal musings of Adam Hartnett, is another unconventional and very rewarding baseball zine. Some popular sports zines, such as *When Saturday Comes* (www.wsc.co.uk), have turned into professionalized periodicals. In 2013, the "multidisciplinary design collective" OWT and *Spiel* magazine issued a book about British football zines titled *From the Stands*, containing artwork from a "State of the Zine" event held at the National Football Museum in Manchester earlier that year.

Cover of the FC St. Pauli fanzine *Übersteiger*, no. 106, 2012. "Übersteiger" means "stepover," the soccer trick. The headlines read: "Unfortunately, I Have to Stay Outside" (top) and "No Police Station at the Back Straight" (bottom). The cover refers to a—successful—campaign against a permanent police station in the St. Pauli stadium. Courtesy of *Übersteiger*.

Social Justice Campaigns

Sports fans are involved in numerous campaigns to right some of the many wrongs of the sports industry. Among the campaigns addressing racism, sexism, and homophobia in sports are the efforts to abolish culturally offensive names and mascots of North American sports teams, such as Washington Redskins, Cleveland Indians, and Chicago Blackhawks. Other campaigns, for example Sports Without War in Canada, object to sporting events being used for military propaganda. Labor-related issues are high on the agenda, too. In 1996, the International Labor Rights Forum initiated the FoulBall campaign, trying to discourage the use of child labor in the production of soccer balls. Sports retail companies, such as Nike and Adidas, have been at the center of the anti-sweatshop campaigns that have emerged in the context of the anti-globalization movement. The process is ongoing.

The academic reader *Sport, Civil Liberties and Human Rights* (2003), edited by Richard Giulianotti and David McArdle, provides an overview of many of the issues at stake; unfortunately, the list price is through the roof. Much more affordable is *Out of Left Field: Social Inequality and Sports* (2011) by Gamal Abdel-Shehid and Nathan Kalman-Lamb—a strong interest in social theory will help you enjoy this. An informative website documenting critical investigations into the world of sports is www.transparencyinsport.org. Online information about the Sports Without War campaign can be found at www.sportswithoutwar.wordpress.com.

Poster by Adbusters. Courtesy of *Adbusters Magazine* (www.adbusters.org).

Antiracist organizing in sports. Top: Banner by the Werder Bremen soccer supporters club Infamous Youth, 2010. Courtesy of Infamous Youth. Bottom left: Logo of the Wisconsin Indian Education Association's "Indian Mascot and Logo Taskforce." Design by Barbara E. Munson. Courtesy of the Wisconsin Indian Education Association (www.indianmascots.com). Bottom right: Poster by the Polish Never Again Association: "Let's kick racism out of the stadiums." Courtesy of Never Again Association (www.nigdywiecej.org).

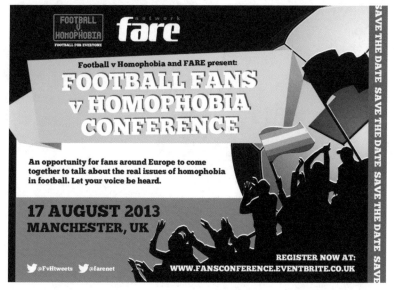

Actions against homophobia in sports. Top left: Banner by the Werder Bremen soccer supporters club Infamous Youth, 2010. Courtesy of Infamous Youth. Top right: Flyer by Queer Football Fanclubs, The European Gay and Lesbian Sport Federation, and others, 2009. Private collection. Bottom: Invitation to the "Football Fans vs. Homophobia" conference organized by FARE (see page 97) in Manchester, England, 2013. Private collection.

FreundInnen der Friedhofstribüne & Wiener Sportklub laden ein zum:

UTE BOCK CUP 2012

GRENZENLOS KICKEN · NO BORDER. NO NATION

LIVE: Chra • Drum:Bock • Florian Horwath • Rene Marschel •
Mieze Medusa & Tenderboy • Susi & Markus • Tingel Tangel • Wild Evel • *Wred*

SPECIALS: Cucina Durruti • Creative Tribune • Haare lassen & Ausflippen • Kaffeefabrik • Kinderecke • Scheiberlkistn • Simultanschach

TEAMS: Alsergrund Ladies • Arge ToR! • Ballerinas • Ballesterer • Deserteurs- und Flüchtlingsberatung • Die Gaynialen • Döblinger Kojoten • Dynama Donau • FC Start • Friedhofstribüne • Goodball • Grüner Stern Brigittenau • Kama SuperSoccer • Lok Danger • Mund.Werk • Okta TV • Streetwork Wieden • Neuer Start • Schwarz-Weiss Augustin • Seri Netzwerk • Stahlstadt Sox • Tebe Party Army • Telekopie • Ute Bock United • Vfl Bura Bura 00

Sonntag 3.Juni 2012 ab 11:00 – ganztägig

Wiener Sport-Club Platz • Alszeile 19 • 1170 Wien

Öffentliche Anbindung: 10, 43, 44, S45 • Fahrradfreundlich Bei jedem Wetter • Eintritt Frei

Fußball und Party zu Gunsten des Vereins Ute Bock – Menschenwürde braucht keine Papiere!

Tournaments

Fed up with the commercialization of organized sports, many sports enthusiasts with progressive leanings started to organize their own events in the 1990s. The competitive character is usually secondary to the communal one, and most events are tied to social and political causes. There is, for example, the annual Mondiali Antirazzisti in Italy, the Anti-Racism World Cup in Belfast, the Come Together Cup in Germany, or the Ute Bock Cup in Austria. Sometimes sports events are organized during political protests: in 2008, Japan's Rage and Football Collective arranged an Anti-G8 Football Cup on the island of Hokkaido, and in 2012, Games Without Borders were held during the London Olympics in Calais, France, where many refugees become stranded on their way to the UK.

Relevant websites are www.mondialiantirazzisti.org, www.antiracismworldcup.com, www.come-together-cup.de, and www.utebockcup.at. An interesting account of attending a wide variety of grassroots sports events is *The Other Olympics* (2012) by Matt Roebuck.

Poster for the migrant solidarity soccer tournament Ute Bock Cup in Vienna, 2012. Design by Mops & Gerry. Courtesy of Freund_innen der Friedhofstribüne (www.friedhofstribuene.at).
Overleaf: Poster for the 2009 Mondiali Antirazzisti. Design by .zersetzer. |||| ||| freie grafik (www.zersetzer.com). Courtesy of the artist.
Poster for the anarchist Matches & Mayhem football tournament in Chicago, 2000. Design by Tony Doyle. Courtesy of Interference Archive, Brooklyn, New York (www.interferencearchive.org).

Top: Mural in support of London's Southbank skating site. Photograph by Garry Knight. Bottom left: "Skating against Nazis: Demonstration for an Antifascist Youth Culture." From de.indymedia.org. Bottom center: Poster for the Diada Skatepunk Festival in Barcelona, 2011. Private collection. Bottom right: "Skateboarding Is Not a Crime" is a popular slogan used in protesting the anti-skateboarding laws passed in numerous municipalities since the 1970s. Private collection.

Skateboarding

In the 1980s, skateboarding—and, in its wake, snowboarding—became the sport of choice for many teenagers, not least those involved in the punk subculture. As with any such trends, two currents existed side by side from the beginning: one heading toward mainstream culture and commercialization, the other defending independent, DIY values. While the Norwegian snowboarding legend Terje Haakonsen to this day boycotts Olympic competitions as a betrayal of snowboarding's founding principles, others are happy to use the opportunity to improve their brand. In any case, boarding culture remains an integral part of the DIY underground and is perhaps the prototype modern alternative sport. Projects such as Skateistan, which uses skateboarding as a "tool for empowerment" and operates in countries like Afghanistan and Cambodia, have related its spirit to concrete social interventions.

Thrasher magazine has been a major source for skateboarding culture since 1981. Among the books exploring skateboarding history, Jocko Weyland's *The Answer Is Never: A Skateboarder's History of the World* (2002) and the anthology *Life and Limb: Skateboarders Write from the Deep End* (2004) are entertaining reads. An art favorite is *The Disposable Skateboard Bible* (2009) by Sean Cliver. The history of the legendary Z-Boys, a highly influential group of skateboarders in mid–1970s California, has been told in the form of a photo book (*Dogtown: The Legend of the Z-Boys*, 2000), a documentary film (*Dogtown and Z-Boys*, 2001), and a dramatic feature film (*Lords of Dogtown*, 2005). The documentary *Skatopia: 88 Acres of Anarchy* (2010) portrays the skateboarding community of the same name in rural Ohio. *Rollin' through the Decades* (2005) tells the story of the Southbank skating spot in London. The Long Live South Bank website www.llsb.com is dedicated to the preservation of the site, which has been threatened by development plans for a number of years. The website of the Skateistan project is www.skateistan.org. An interesting documentary about snowboarding, including its relation to the skateboarding and punk community, is *We Ride: The Story of Snowboarding* (2013).

Top: Flyer for a Critical Mass bike ride in Richmond, Virginia, May 2013. Private collection. Bottom: The Roots of Compassion Vegan Cycling Team in 2012. Photograph by Thomas Damm.

Cycling

While noncompetitive sports such as rock climbing, hiking, jogging, and parkour are popular with contemporary activists, no sport plays as central a role in progressive and radical communities as cycling, considered to be an environmentally friendly, sustainable, healthy, and affordable means of transportation—in many ways tied to the values of cycling in the workers' sports movement. There are numerous self-managed activist bicycle repair and exchange places, and the global Critical Mass network organizes bike rides under the motto "We aren't blocking traffic, we are traffic." Some folks even enter the competitive realm: the German Roots of Compassion collective, a popular distributor of vegan products and related literature, founded its own cycling team in 2011.

One of the best overviews of cycling from an activist perspective is *One Less Car: Bicycling and the Politics of Automobility* (2010) by Zack Furness. *Shift Happens! Critical Mass at 20* (2012), tells the Critical Mass story; one of the book's editors, Chris Carlsson, also edited *Critical Mass: Bicycling's Defiant Celebration* (2002). A beautiful pamphlet is *Under the Sign of the Bicycle* (2002) by Alon K. Raab. For practical advice, there is *Bicycle! A Repair & Maintenance Manifesto* (2013, orig. 2005) by Sam Tracy. *Still We Ride* (2005) documents the 2004 crackdown on Critical Mass in New York City. For online information on Critical Mass, the San Francisco site (www.sfcriticalmass.org) is a good place to start. Information about the Roots of Compassion cycling team can be found at www.cycling.rootsofcompassion.org. For those who prefer running over bicycling, there is the book *Run Wild* (2012) by the former Chumbawamba guitarist Boff Whalley, and the pamphlet *Parkour for Commies: A Guide to Urban Free Running* (2005).

RIDE DAILY, CELEBRATE MONTHLY!

CRITICAL MASS

Every month cyclists in over 200 cities throughout the world ride to celebrate bike awareness and pollution-free transit.

Everyone Can Participate! Just Show Up!

We're not stopping traffic, WE ARE TRAFFIC!

Grab Your Bike! Let's Go!

Free of Emissions Free Parking Free feeling

LAST FRIDAY OF EVERY MONTH!

Meet at **5:30 PM Westlake Square** Downtown Seattle

A pre-ride group leaves from Red Square in the U-District at 5:00 PM

Attention Bikers! Support Bicycle Transportation and Recreation!

www.seattlecriticalmass.org

Flyer for Critical Mass Seattle, Washington, ca. 2007.
From www.seattlecriticalmass.org.
Facing page: Flyer for a Critical Mass bike ride in Bloomington/Normal, Indiana,
May 2012. Private collection.

Top: The two issues of the *Radical Cheerleaders* zine published by Holly Casio and Seleena Daye in 2002. Photograph courtesy of Holly Casio, Radical Cheerleaders UK (www.coolschmool.com). Bottom: *Brittans damgympa* in action, 2009. Photographs by David Magnusson (www.davidmagnusson.se).

Radical Cheerleading

In the late 1990s, radical cheerleading emerged as a new phenomenon in the context of creative protest culture. While it might put greater emphasis on creative chants than athleticism, it is a radical adaption of traditional athletic activity and has become a refreshing and inspiring element of many protests, featuring extravagant outfits, impressive choreography, and memorable demands for social justice—including classics such as "Devastation and Exploitation / Won't be solved by corporations!," "That's bullshit! / Get off it! / The enemy is profit!," and "Hoo Ha! / God Damn! / We will stop your evil plan!"

Radical cheerleading has drawn inspiration from performance arts (in particular street theater), the Riot Grrrl movement, and agitprop. While it might have lost in popularity over the last few years, it is destined to survive in one form or another. Projects like Stockholm's *Brittans damgympa*, propagating collective public exercise in order to "take over the streets before the Nazis do," prove the point.

Sadly, there is no book-length account of radical cheerleading, but an excellent essay is available online at www.hemisphericinstitute.org, namely Jeanne Vacarro's "Give Me an F: Radical Cheerleading and Feminist Performance" (originally published in *Women and Performance: A Journal of Feminist Theory*, no. 2, 2005). Other useful online resources include www.theradicalcheerleaders.wordpress.com, the "Guide to Radical Cheerleading" at www.mookychick.co.uk, and the Facebook page "Adventures in Radical Cheerleading." More about *Brittans damgympa* can be found at www.brittansdamgympa.wordpress.com.

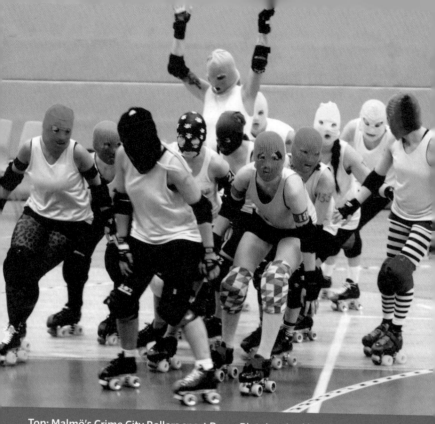

Top: Malmö's Crime City Rollers sport Pussy Riot–inspired balaclavas at a 2012 bout in Stockholm. Bottom: Battle of the Nordic Light 2011. Photographs by Ina Hallström.

Roller Derby

A sport that has caught on with many radicals is roller derby, an event involving two roller skating teams trying to overtake opponents on an oval track. Roller derby has its origins in the 1930s, but its current popularity is due to a revival that started in the early 2000s, strongly inspired by DIY culture, punk, feminism, and camp aesthetics (often described as "outrageous," "shocking," or "excessive"). The sport is almost exclusively practiced by women. While only a few teams are overtly political and the danger of commercialization is palpable, roller derby is an empowering, inspiring, and fun environment for practicing and watching sports. With players carrying names like Scary Wollstonecraft, Wuthering Frights, and Polygamy Winehouse, it is hard to go wrong.

Frank Deford's *Five Strides on the Banked Track: The Life and Times of the Roller Derby* (1971) is an account of classic roller derby. Among publications about the roller derby revival are Catherine Mabe's *Roller Derby: The History and All-Girl Revival of the Greatest Sport on Wheels*, Melissa "Melicious" Joulwan's *Rollergirl: Totally True Tales from the Track* (both 2007), and Jennifer "Kasey Bomber" Barbee and Alex "Axles of Evil" Cohen's *Down and Derby: The Insider's Guide to Roller Derby* (2010). *Blood and Thunder*, *fiveonfive*, *Hit and Miss*, and *Inside Line* are popular magazines. The film *Roller Derby Mania* (1986) has plenty of classic roller derby footage. The documentary *Hell on Wheels* (2007) tells about the origins of the roller derby revival in Austin, Texas. Numerous other documentaries about roller derby leagues have been released in recent years. While some of them overstress the "Wow, it's girls hitting each other!" factor, they all provide insights into the culture. Less suitable is the Drew Barrymore–directed drama *Whip It!* (2009), although it has reputedly inspired women to give the sport a try. The website of the Women's Flat Track Derby Association is www.wftda.com.

Design for a Köpi Fight Club T-shirt. Drawing by Mike Spike Froidl
(www.mike-spike-froidl.de).

Fight Clubs

As a means to prepare activists for self-defense and militant confrontations with fascists, Antifa fight clubs have been established in many countries. One of the best-known exists at the legendary Köpi squat (named after Köpenicker Straße) in Berlin. It was inspired by a club with an even longer history, namely the one at Munich's Kafé Marat. Peter Seyferth, once a trainer there, summarizes his experiences thus:

> The main styles were Modern Arnis and Thai Boxing. We called our group "AKAB" (I had just been busted for an "ACAB" button), but there was no consensus on what that actually stood for. Some preferred "Alkoholiker können auch boxen" (Alcoholics can box, too), while I liked "Arbeitskreis angewandte Brutalität" (Working Circle for Applied Brutality). We tried to manage our affairs in horizontal consensus meetings but we were only partially anarchist. Punk and alcohol were important for our self-image and this influenced our behavior. Machismo was a problem, and, against our intentions, a small group of young men, including me, acted as anarcho-leaders.

The accusation of machismo is commonly levied against Antifa fight clubs, but these are not the only choice for radicals. There are plenty of feminist groups teaching self-defense, and entire schools, such as Wendo, have been established for this purpose.

For fans of charming lo-fi filmmaking, the half-hour documentary about the Kafé Marat fight club, *AKAB* (2004), is well worth watching. Online info about the Köpi Fight Club is available at www.koepi137.net/fightclub. Clips about other Antifa fight clubs can be found under "Anarchism and Martial Arts" on various Indymedia sites. More information about Wendo is available at www.wendo.ca.

From the cover of the *Give 'em the Lumber* zine no. 2 (2006).

Album cover of the Hanson Brothers' *Gross Misconduct* (1992). Design by John Yates. Private collection.

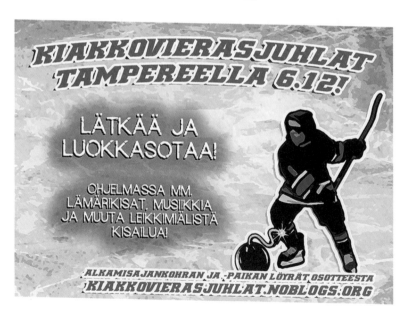

Hockey

"Let's be honest. Hockey is the most punk rock sport. It's fast, brutal, and perfect for those of us with ADD." These are the words of the Pittsburgh punk band Anti-Flag, posted on their website to promote a T-shirt with the slogan "Drop Pucks, Not Bombs." Indeed, ice hockey is popular among many punk bands—unsurprisingly, the further north you go the more this proves true. Winnipeg's Comeback Kid is named after the ice hockey legend Mario Lemieux, NoMeansNo has a famous side project called the Hanson Brothers, named after the notorious brawlers of the cult film *Slap Shot*, the Zambonis exclusively play hockey songs, and D.O.A. has provided hockey classics such as "Give 'em the Lumber," which also serves as the name for an ice hockey punk zine from San Francisco.

Although it has nothing to do with punk or radical politics, the movie *Slap Shot* (1977) is a must-see for anyone who has not yet indulged. Online research on the mentioned bands can be conducted at www.comeback-kid.com, www.nomeanswhatever.com, www.thezambonis.com, and, fittingly, www.suddendeath.com (Sudden Death Records is a label run by D.O.A.'s Joey "Shithead" Keithley). A must are also the Puck Rock compilations presented by Johnny Hanson (vol. 1, 1994, vol. 2, 2004). Articles from the *Give 'em the Lumber* zine can be found at www.giveemthelumber.wordpress.com.

Left: Poster for the "Hockey Guest Party" in Tampere, Finland, December 6, 2013, with a program including "a slap shot competition, music, and other fun games." The "Hockey Guest Party" was a "class war" protest directed against elitist and chauvinistic notions of national unity (December 6 is Finland's Independence Day). Courtesy of www.kiakkovierasjuhlat.noblogs.org.

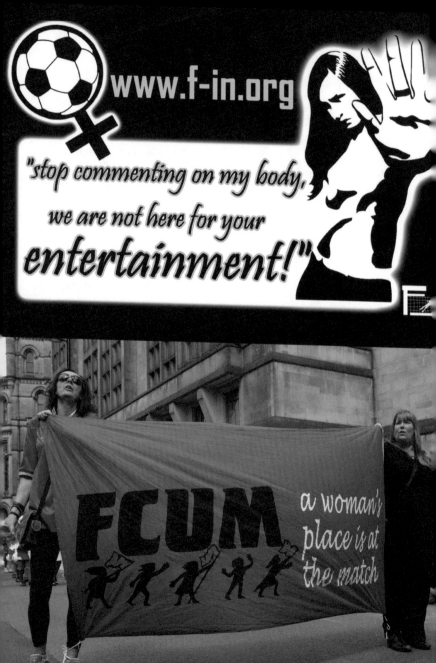

"A Woman's Place Is..."

Skateboarding, fight clubs, hockey...Mainstream culture is often reproduced in alternative circles, and male dominance in alternative sports is no exception. Yet, this does not go unchallenged. Roller derby is one notable exception. There are also initiatives, such as *F_in: Frauen im Fußball* (see page 97), which strengthen the role of women supporters. Meanwhile, trailblazers for women's rights in sports (and beyond), such as the tennis players Billie Jean King and Martina Navratilova, continue to inspire. The jury is still out on whether gender-integrated sports or women-only sports are the more promising path to gender equality, but there is broad agreement on the basis for progress resting on sporting environments that are shaped and created by everyone.

Feminist studies on sports include Cara Carmichael Aitchinson's *Sport and Gender Identities: Masculinities, Femininities and Sexualities* (2007) and Varda Burstyn's *The Rites of Men: Manhood, Politics and the Culture of Sport* (1999). Self-titled autobiographies by both Billie Jean King and Martina Navratilova were published in the 1980s. There are several commercial films about women in sports, such as the Hollywood production *A League of Their Own* (1992), portraying the 1943–1954 All-American Girls Professional Baseball League (starring, among others, Madonna), and *Bend It Like Beckham* (2002), which, despite rating high in cheesiness, is an important contribution to addressing both sexism and racism in football. In the Iranian drama film *Offside* (2006), women try to sneak into a World Cup qualifier in Tehran, where the line between women cheering for football teams and political protest is very thin. The documentary film *Ready to Fly* (2012) tells about the rough road to the Olympics for women ski jumpers—a modern-day tale about deeply entrenched patriarchal power structures.

Top: Sticker by *F_in: Frauen im Fußball*. Courtesy of *F_in*. Bottom: Banner at the Manchester Day Parade 2011. "FCUM" stands for FC United of Manchester. Photograph by Mick Dean.

Original "Gay Olympic Games" poster, 1982. Eventually, "Olympic" had to be removed, after the IOC had legally forced the Gay Games organizers to change the name. Courtesy of Kelly Stevens/ Federation of Gay Games. Artist: Geoffrey Graham

GAY OLYMPIC GAMES

SAN FRANCISCO 1982

LGBTQ Sports

While homophobia continues to be a major concern in a sports culture rooted in conservative notions of masculinity, gender, and sexuality, sport has been embraced by the gay and lesbian community for decades. LGBTQ sports events provide a space for people breaking gender and sexuality norms and an opportunity to occupy public space.

Crucial for the history of LGBTQ sports were the first Gay Games in 1982. Originally announced as the Gay Olympic Games, the designation "Olympic" had to be dropped after legal procedures initiated by the International Olympic Committee (IOC). The games themselves could not be stopped, however, and Gay Games have been organized every four years since. There are also EuroGames and World Outgames.

The coming out of gay athletes in mainstream sports remains rare. The story of Justin Fashanu who, in 1990, was the first professional soccer player to come out, is a tragic one: Fashanu took his own life in 1998. In recent years, there have been encouraging signs, such as the largely positive responses to the coming out of the basketball player Jason Collins and the soccer player Robbie Rogers. Hopefully, this sets the stage for the future.

The documentary film *Claiming the Title: Gay Olympics on Trial* (2009) tells the story of the IOC's crackdown on the Gay (Olympic) Games organizers. The documentary film *Take the Flame! Gay Games: Grace, Grit and Glory* (2005) traces the history of the games up to a split in the 2006 organizing committee. Useful websites are: www.gaygames.org, www.eurogames.info, www.glisa.org (Gay and Lesbian International Sport Association, organizer of the World Outgames), www.eglsf.info (European Gay and Lesbian Sport Federation), www.gaysport.info, and www.outsports.com. Justin Fashanu is the namesake for the Justin Campaign (www.thejustincampaign.com), one of the most dedicated campaigns against homophobia in sports.

PARA
SPORTS

ANDRE
PARSO
Entrevista co
presidente do

NATAÇÃ
Preparação
equipe para 2

HARDCORE
Adrenalina sobre rodas

Parasports

The Paralympic movement kicked off in 1960. It was an important initiative for strengthening the recognition of special needs athletes. Today, Paralympic Games are held in conjunction with Olympic Games. Other important parasports events include the Special Olympics World Games, the International Wheelchair and Amputee Sports World Games, and the Deaflympics. One of the most impressive features of parasports is the creativity involved in adapting mainstream sports to the special needs of parasport athletes. Sledge hockey, anyone?

It is interesting to note that some athletes with physical impairments have competed very successfully in mainstream sports. The American gymnast George Eyser, who had lost a leg in a train accident as a youth, won six medals at the 1904 Summer Olympics. Examples such as these challenge categories of (dis-) ability as much as related divisions in the sporting world.

There are a few books exploring the Paralympic movement: Cynthia Peterson and Robert D. Steadward's *Paralympics: Where Heroes Come* (1998), and *The Paralympic Games: Empowerment or Side Show?* (2008), edited by Keith Gilbert and Otto J. Schantz, are both good and affordable. *The Cultural Politics of the Paralympic Movement* (2008) by David Howe, and *Athlete First: A History of the Paralympic Movement* by Steve Bailey (2008) are also good but less affordable. *Disability, Sport and Society: An Introduction* (2008) by Nigel Thomas and Andy Smith goes beyond the Paralympic movement. So does the documentary film *Murderball* (2005), an impressive portrayal of the American wheelchair rugby team. Online information about the biggest parasports events can be found at www.paralympic.org, www.specialolympics.org, www.iwasf.com (International Wheelchair and Amputee Sports Federation), and www.deaflympics.com. The Paralympic Sports Association website is www.parasports.net.

Cover of the Brazilian magazine *Parasports*, no. 1, 2013. Courtesy of *Parasports* (www.parasports.com.br).

Amsterdam Never

SINE PANEM ET NON CIRCENSES

NOlympics

The Olympic Games, the world's biggest sporting event, have become the target of numerous protest movements. The first broad, and successful, campaign was the one against the Amsterdam bid to host the summer games in 1992. An equally strong campaign contributed to preventing Berlin from hosting the 2000 summer games. More recently, the Chicago bid for the 2016 summer games was rejected amid widespread opposition, and around the world a number of referendums saw local communities reject bids by their city leaders, for example in Munich, Innsbruck, and Kraków (note that both Munich and Innsbruck are former host cities).

The protests do not stop, however, once a bid is successful. Whether the focus has been on social cleansing (Sydney 2000), corruption (Salt Lake City 2002), costs (Athens 2004), militarization (Turin 2006), human rights (Beijing 2008), colonialism (Vancouver 2010), or gentrification (London 2012), no Olympic Games of the past fifteen years have been the universal celebrations the IOC likes to brag about. Despite differences in focus, the anti-Olympic protest movements all address common themes: a lack of transparency and democracy, the priority of multinationals' interests over local ones, environmental destruction, unsustainable development, greed, and disregard for social causes. For many, the organizational structure of the IOC is enough to get riled up. In the *New Left Review*, Jules Boykoff has described the organization thus: "Based in Lausanne, Switzerland, where it is registered as a not-for-profit NGO, and enjoying tax exemptions wherever it touches down, the IOC ... is subject to no independent financial audit; the ultimate destination of much of the revenue that flows

Poster against Amsterdam's Olympic bid for the 1992 Summer Games, 1986. Courtesy of Eric Duivenvoorden, editor of the book *Met emmer en kwast: veertig jaar Nederlandse actieaffiches 1965–2005* (2005).

...8 ...9 ...aus !
knock out Olympia !

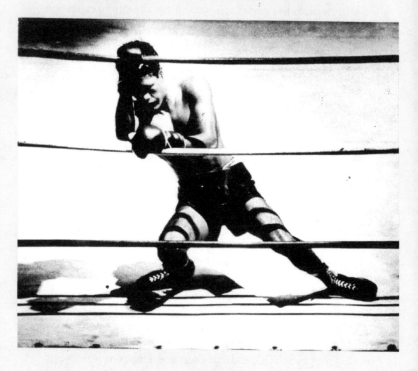

17. -21. april ioc prüfungskomission in berlin:
geben wir ihnen das ergebnis, das sie brauchen !

Demo am Sonntag, 18.4.93
Treffpunkt Checkpoint Charlie
15.00 Uhr

into its coffers remains mysterious, the salaries of IOC executives unreported." Gareth Edwards, who maintains the sports blog *Inside Left* (see page 17), has called the Olympics "an event that effectively nationalises organisational and infrastructure costs whilst ensuring maximum profitability for multinational corporations." It doesn't help either that two longtime presidents of the IOC, Avery Brundage (1952–1972) and Juan Antonion Samaranch (1980–2001), openly sympathized with fascist ideas.

Apart from their seductive power as a spectacle, there are also sound reasons why the Olympics still capture the attention of the masses: there is something undeniably powerful in bringing together a bigger diversity of people than any other world event, most of them attending in high spirits. The media focus on the records and the medalists often overshadows the community formed by many athletes away from the limelight. If this sense of community can be strengthened and prolonged beyond the games, while competitiveness, nationalism, and commercialism are tamed, there might be a promising future for the Olympic Games after all.

A number of books provide thorough critiques of the IOC and the Olympic industry. A classic is Vyv Simson and Andrew Jennings's *The Lord of the Rings: Power, Money and Drugs in the Modern Olympics* (1992). Andrew Jennings has published a couple of follow-up volumes, namely *The New Lords of the Rings: Olympic Corruption and How to Buy Gold Medals* (1996), and *The Great Olympic Swindle: When the World Wanted Its Games Back* (2000, with Clare Sambrook). Other important titles include *Five Ring Circus: Money, Power and Politics at the Olympic Games* (1984), edited by Alan Tomlinson and Garry

Poster announcing a demonstration against Berlin's bid for the 2000 Summer Games, 1993. Courtesy of HKS 13.

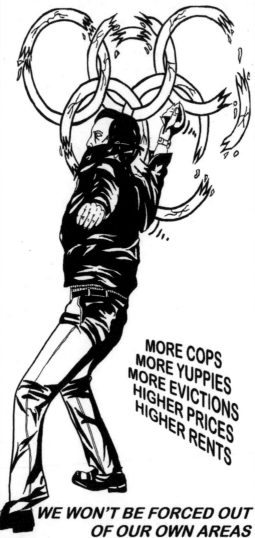

Whannel, *Inside the Olympic Industry: Power, Politics, and Activism* (2000) by Helen Jefferson Lenskyj, *Five-Ring Circus: Myths and Realities of the Olympic Games* (2008) by Christopher Shaw, and *Watching the Olympics: Politics, Power and Representation* (2011), edited by John Sugden and Alan Tomlinson. Mark Perryman, who runs the witty Philosophy Football outfit (www.philosophyfootball.com), published two books about local resistance to the 2012 London Olympics: *Why the Olympics Aren't Good for Us, and How They Can Be* (2012), and the post-event analysis *London 2012: How Was It for Us?* (2013). Online information about different Olympic protest campaigns can be found at www.gamesmonitor.org.uk.

12,000 POLICE OFFICERS. 13,500 MILITARY PERSONNEL. 20,000 SECURITY GUARDS. 1,000 U.S. SECURITY PERSONNEL. 300 MI5 AGENTS. WARSHIPS. DRONES. SNIPERS.

LONDON OLYMPIGS 2012. ENJOY THE GAMES!

Original image by Charlotte Gilhooly - http://www.flickr.com/people/30813728@N00/

Above: Poster from the "Anti-Olympics Poster Competition" at www.blowe.org.uk
Facing page: Poster against the 2000 Summer Games in Sydney, Australia. From the Australian *Angry People* journal, no. 14, 1997.

SHUT DOWN THE OLYMPIC BID!

Say NO to the Chicago 2016 Olympic Games.

Thursday April 2nd, 5pm at Federal Plaza (50 W. Adams)

The International Olympic Committee will be in town from April 2-8th to evaluate Chicago's potential as a Host City for the 2016 Summer Olympics. Let them know that Chicago 2016 does not speak for the people of Chicago. Let them know that Chicagoans have other priorities. Let them hear your voice. RALLY. SPEAK OUT. PROTEST. SHUT DOWN THE OLYMPIC BID!

We need Better Hospitals, Housing, Schools, and Trains - Not Olympic Games. They Play and We Pay. NO GAMES

For more email nogameschicago@gmail.com or call 312.235.2873

nogameschicago.com

NO GAMES
★ 2 0 1 6 ★
CHICAGO

nogameschicago.com

BETTER HOSPITALS ★ HOUSING ★ SCHOOLS AND TRAINS

If the Mayor wants a world-class city, then build us world class schools, health care, mass transit and parks. We're already paying world-class taxes! We say "NO!" to a $4 billion plus three-week party!

Flyer announcing a protest against Chicago's bid for the 2016 Summer Games, 2009. Design by Bob Quellos. Courtesy of No Games Chicago (www.nogameschicago.com).

Homelessness, Ecological Destruction, Corporate Invasion of Native Lands, Huge Profits for Corporations, Massive Public Debt, Increased Police Repression & Surveillance...
Let's Stand Together & Show the World There is:

NO TIME for the Olympics!

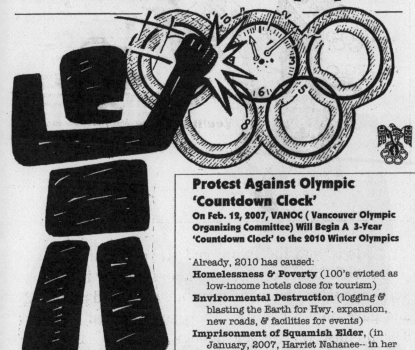

Protest Against Olympic 'Countdown Clock'

On Feb. 12, 2007, VANOC (Vancouver Olympic Organizing Committee) Will Begin A 3-Year 'Countdown Clock' to the 2010 Winter Olympics

Already, 2010 has caused:
Homelessness & Poverty (100's evicted as low-income hotels close for tourism)
Environmental Destruction (logging & blasting the Earth for Hwy. expansion, new roads, & facilities for events)
Imprisonment of Squamish Elder, (in January, 2007, Harriet Nahanee-- in her '70s-- was sentenced to 14 days in jail for protesting highway expansion at Eagle Ridge in N. Vancouver, May 2006).

Monday, Feb. 12, 2007
@ 12 Noon, Vancouver Art Gallery

Speakers & Drummers from Secwepemc, St'at'imc & Lil'wat, Native Youth Movement, Anti-Poverty Committee, No One Is Illegal, DERA, Wild Earth, SF-PIRG, and Others.
Bring Drums & Noise-makers.
Organized by: Anti-Olympic Coalition

Flyer announcing a protest against the 2012 Winter Games in Vancouver, 2007.
Design by Gord Hill. Courtesy of the artist.

Soccer World Cups II

Protests against Men's Soccer World Cups have intensified in the last decade. The international soccer association FIFA (*Fédération Internationale de Football Association*) is criticized for similar reasons as the IOC: it is accused of being an undemocratic organization ruled by corporate interests, of exploiting public funds, of putting on a spectacle, and of showing little regard for human rights, labor issues, and environmental sustainability.

The biggest anti–World Cup protests to this day have taken place in Brazil, leading up to the 2014 tournament. The main focus of the protests was the blatant gap between World Cup costs on the one hand and investments in Brazil's social infrastructure on the other. During the World Cup itself, heavy-handed police and the usual national consensus kept protests at bay, but they were ever present. Protests also have to be expected with regard to the upcoming World Cups in Russia (2018) and Qatar (2022), with a resounding international echo.

Investigative journalists have taken a harsh look at the FIFA reality. The most staggering account has been Andrew Jennings's *Foul! The Secret World of FIFA: Bribes, Vote Rigging and Ticket Scandals* (2006). Dave Zirin has written a book on the situation in Brazil, *Brazil's Dance with the Devil: The World Cup, the Olympics, and the Fight for Democracy* (2014). *Fahrenheit 2010* (2009) is a documentary film about the 2010 Men's World Cup in South Africa; South African TV stations refused to air it. The campaign *Rerun the Vote* draws attention to labor rights violations in the buildup to the 2022 World Cup in Qatar (www.rerunthevote.org).

Poster by the "Militant Class-Struggle Students' Union" RECC (*Rede Estudantil Classista e Combativa*) against the 2014 Men's Soccer World Cup in Brazil. The slogan reads, "Without Rights, There Won't Be a World Cup!" From www.redeclassista.blogspot.com.

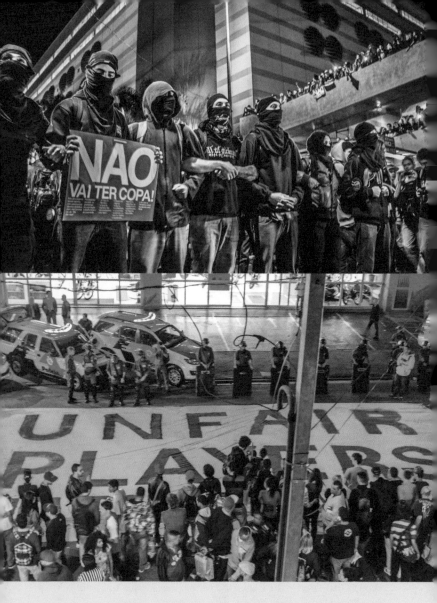

Impressions from protests against the 2014 Men's Soccer World Cup in Brazil. The sign on p. 146 says "There Won't Be a World Cup!" Photographs by Eli Simioni (www.simionifotografia.com), taken in São Paulo.

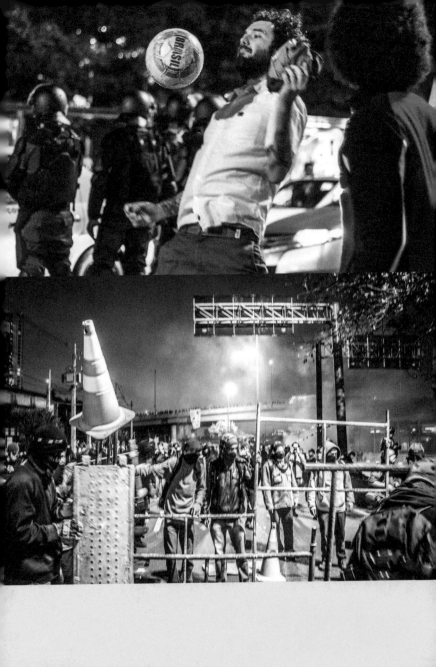

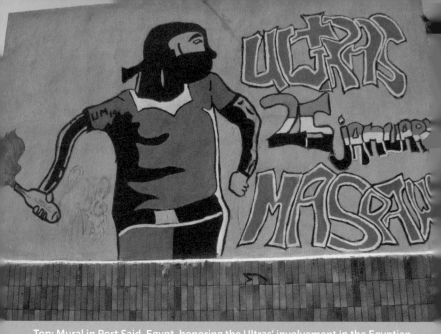

Top: Mural in Port Said, Egypt, honoring the Ultras' involvement in the Egyptian uprising of 2011. From www.opendemocracy.net. Bottom: Graffiti uniting Istanbul's main Ultra groups, Carsi (Beşiktaş), GFB (Fenerbahçe), and ultrAslan (Galatasaray), during the 2013 Gezi Park occupation in Istanbul, Turkey. Photograph by Ekim Çağlar.

Ultras

The involvement of soccer fans—more precisely, Ultras—in the popular uprisings in the Middle East, especially in Egypt and Turkey, has received a lot of media attention.

Ultras are a particular brand of soccer supporters that emerged in Italy in the late 1960s with a strong focus on loyalty, self-determination, and anti-commercialism. While it is impossible to pigeonhole the Ultra movement politically (in the Ukraine in 2014, for example, most Ultras fought on the side of nationalist and fascist groups), Gerd Dembowski, a longtime spokesperson for BAFF (see page 97), has put the challenge well: "It would be a grave sin for the left to ignore the Ultras as an important new form of youth culture. It is essential to have a left-wing presence within groups that are instinctively against commercialization, consumerism, discrimination, and repression; especially, when these groups are very attractive to a lot of young people!"

With respect to the Ultras' role in the Middle Eastern uprisings, the journalist Ekim Çağlar, an active participant in the Gezi Park protests in Turkey, has identified four major aspects in an article for the Norwegian magazine *Josimar*: a political rhetoric that's more appealing than that of the traditional left; self-esteem; a potential for broad mobilization; and extensive experience with police repression. Food for thought for all political activists.

There is no book-length study on the Ultra phenomenon in English yet, but there are some interesting books on the cultural and political role of soccer in the Middle East: James Montague's *When Friday Comes* (2013, orig. 2008), James M. Dorsey's *The Turbulent World of Middle East Soccer* (2014), and the academic reader *Soccer in the Middle East* (2014), edited by Alon Raab and Issam Khalidi. James M. Dorsey also maintains the blog www.mideastsoccer.blogspot.com. The documentary film *Istanbul United*, depicting the role of the Ultras in the Gezi Park uprising, was released in 2014.

Athlete Activists

While sports fans are becoming increasingly political, the same cannot necessarily be said about athletes. When, in February 2012, the football player Joseph Williams joined a hunger strike in support of protesting service workers at the University of Virginia, it seemed so unusual that the story received worldwide attention.

Among the reasons for athletes' low political profile are dependency on owners and sponsors and a culture of obedience that weeds out rebellious types. Yet there have been exceptions since the days of Roberto Clemente and Sócrates: in the 1990s, St. Pauli goalkeeper Volker Ippig used to greet supporters with a clenched-fist salute; in 1997, the soccer player Robbie Fowler supported striking dockworkers in Liverpool; in 2003, the Zimbabwean cricketers Henry Olonga and Andy Flower wore black armbands at the World Cup "mourning the death of democracy" in their home country; in 2004, the baseball player Carlos Delgado refused to stand during the playing of "God Bless America" in the break of the seventh inning; in 2009, the martial arts fighter Jeff Monson got charged with spray-painting anarchist slogans on the Washington State Capitol in Olympia; in 2010, the Phoenix Suns played with "Los Suns" shirts after draconian anti-immigration laws were enforced in Arizona; and since 2013, several high-profile athletes in the U.S., particularly in the NBA and NFL, have been protesting the deaths of unarmed African-Americans at the hands of law enforcement.

After Joseph Williams's hunger strike, *Sports Illustrated* ran an article by Gary Smith titled "Why Don't More Athletes Take a Stand?" (July 9, 2012). It is a good starting point for the discussions we need to have.

Steve Nash of the Phoenix Suns playing in a "Los Suns" shirt. Drawing by Findus, illustrator of comics such as *Kleine Geschichte des Anarchismus* (2009) and *Kleine Geschichte des Zapatismus* (2011).

Pennants by Dylan Miner (www.dylanminer.com).

Conclusion

Banner by FC United of Manchester supporters during the Manchester Day
Parade 2013. Photograph by Mick Dean.

The current sports industry seems overwhelmingly powerful. Unfortunately, the protests and initiatives mentioned in this book are marginal phenomena in the contemporary world of sports, and many people, even sports fans, are hardly aware of them. Yet, they are not without influence. On rare occasions, they can make worldwide headlines, like Tommie Smith and John Carlos's clenched-fist salute or Ultras in Egypt fighting political rulers and their lackeys. Popular criticism of the IOC and FIFA is on the rise. And the network of community and grassroots sports clubs is constantly expanding. Change is looming in sports. Whether we'll witness another mass movement, as it existed in Europe in the early twentieth century, is difficult to say, but there is no harm in aiming high.

A couple of final notes: In critiquing the current world of sports, it is not enough to simply stress the ideal of amateurism. Only in the context of a broad socialist movement can amateurism—as an expression of modesty and levelheadedness—be embraced by the working class. Otherwise, professional sports remains one of the few ways out of misery. It is also not enough to cite "tradition" in our opposition to commercialism. The upheaval of traditional sports culture has also led to more diversity. Change itself isn't bad, the question is how things change. While corporate globalization is terrible for sports, migration is not. Stopping social developments is futile (and loaded with political problems); instead, we need to separate the good from the bad.

What would an ideal world of sports look like? There would be no more superstars, no more billion dollar contracts, no more endless hours of televised sports, no more fits about "superhuman" athletic achievements, etc. Instead, sports would help us to meet people, equip us with social skills, bring fun to our everyday lives (don't forget its artistic and aesthetic qualities), and nurture our mind and body. There would be a place in sports for everyone, not only for those who run the fastest, hit the hardest, and jump

Back cover of the *Oregon Avenue Octopi 2011 Yearbook*. Courtesy of Oregon Avenue Octopi.

the highest. Body norms would be history. And fair play would be everyone's guiding principle, just as it should be in society overall.

There is no need for people not interested in sport to become interested in it. But being interested in sport does not mean that one cannot be a revolutionary. Sport is as important a political battlefield as any other. Considering how big a factor it is in many people's life, it might even be a particularly important political battlefield. Imagine all the right messages sent out at sports events instead of conservative propaganda and commercial crap. This would be hugely beneficial for everyone, regardless of whether you'd want to watch the game or not.

The goal is not to weigh down the fun in sports with political and moral baggage. The goal is merely not to separate sports from liberation. In fact, this makes everything twice as much fun.

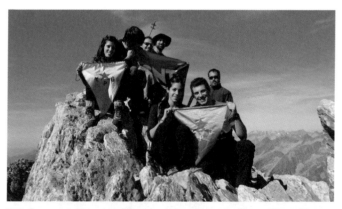

October 2014, Mount Vallibierna, Pyrenees: members of Creu Negra Duatlètica (see page 101) and allies display YPG and YPJ flags—alongside one of the anarchosyndicalist union CNT—in solidarity with the Kurdish struggle in Rojava (Syrian Kurdistan). Photo courtesy of Eloi Martinez.

About the Author

Gabriel Kuhn is an Austrian-born author and translator living in Stockholm, Sweden. He is a former semiprofessional soccer player and a cofounder of the community sports club 17 SK. His book *Soccer vs. the State: Tackling Football and Radical Politics* was published by PM Press in 2011. He is also the editor of *Sober Living For the Revolution: Hardcore Punk, Straight Edge, and Radical Politics* (2010), *All Power to the Councils! A Documentary History of the German Revolution of 1918–1919* (2012), and *Turning Money into Rebellion: The Unlikely Story of Denmark's Revolutionary Bank Robbers* (2014).

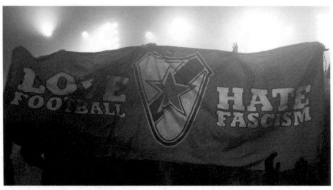

Banner by the antifascist sports club Roter Stern Leipzig. Courtesy of Roter Stern Leipzig '99 e.V.

ABOUT PM PRESS

PM Press was founded at the end of 2007 by a small collection of folks with decades of publishing, media, and organizing experience. PM Press co-conspirators have published and distributed hundreds of books, pamphlets, CDs, and DVDs. Members of PM have founded enduring book fairs, spearheaded victorious tenant organizing campaigns, and worked closely with bookstores, academic conferences, and even rock bands to deliver political and challenging ideas to all walks of life. We're old enough to know what we're doing and young enough to know what's at stake.

We seek to create radical and stimulating fiction and non-fiction books, pamphlets, T-shirts, visual and audio materials to entertain, educate and inspire you. We aim to distribute these through every available channel with every available technology—whether that means you are seeing anarchist classics at our bookfair stalls; reading our latest vegan cookbook at the café; downloading geeky fiction e-books; or digging new music and timely videos from our website.

PM Press is always on the lookout for talented and skilled volunteers, artists, activists and writers to work with. If you have a great idea for a project or can contribute in some way, please get in touch.

PM Press
PO Box 23912
Oakland, CA 94623
www.pmpress.org

FRIENDS OF PM PRESS

These are indisputably momentous times—the
financial system is melting down globally and the
Empire is stumbling. Now more than ever there is a
vital need for radical ideas.

In the seven years since its founding—and on
a mere shoestring—PM Press has risen to the formidable challenge
of publishing and distributing knowledge and entertainment for the
struggles ahead. With over 300 releases to date, we have published an
impressive and stimulating array of literature, art, music, politics, and
culture. Using every available medium, we've succeeded in connecting
those hungry for ideas and information to those putting them into
practice.

Friends of PM allows you to directly help impact, amplify, and revitalize
the discourse and actions of radical writers, filmmakers, and artists. It
provides us with a stable foundation from which we can build upon our
early successes and provides a much-needed subsidy for the materials
that can't necessarily pay their own way. You can help make that
happen—and receive every new title automatically delivered to your
door once a month—by joining as a Friend of PM Press. And, we'll throw
in a free T-shirt when you sign up.

Here are your options:

- **$30 a month** Get all books and pamphlets plus 50% discount on all
 webstore purchases

- **$40 a month** Get all PM Press releases (including CDs and DVDs)
 plus 50% discount on all webstore purchases

- **$100 a month** Superstar—Everything plus PM merchandise, free
 downloads, and 50% discount on all webstore purchases

For those who can't afford $30 or more a month, we're introducing
Sustainer Rates at $15, $10 and $5. Sustainers get a free PM Press
T-shirt and a 50% discount on all purchases from our website.

Your Visa or Mastercard will be billed once a month, until you tell us to
stop. Or until our efforts succeed in bringing the revolution around. Or
the financial meltdown of Capital makes plastic redundant. Whichever
comes first.